OUTDOOR
DECORATING
and Style Guide

DEDICATION

This book is dedicated to all who encouraged my love of outdoor living, as well as design, in general, and nurtured my ever-greening thumb, particularly: my mother Lorraine, my father Frank, my mother-in-law Mary, my husband William, my neighbor and gardening guru Marie Keech, my good friend Elena Marcheso Moreno, and my companions Max and Miranda.

NRG

Special thanks to Susan Morgan for her text on pages 8-15.

First published in the United States of America by
Rockport Publishers, Inc.
33 Commercial Street
Gloucester, Massachusetts 01930-5089
Telephone: (978) 282-9590
Fax: (978) 283-2742
www.rockpub.com

Library of Congress Cataloging-in-Publication Data available
ISBN 1-59253-103-2

10 9 8 7 6 5 4 3 2

Design: Rule 29
Layout: Terry Patton Rhoads
Cover Photograph: Jan Verlinde/Stéphane Boens, Architect
Back Flap and Back Cover Photographs: Courtesy of Amdega, Ltd.

OUTDOOR
DECORATING
and Style Guide

QUARRY BOOKS

NORA RICHTER GREER

With a special section by
A. Bronwyn Llewellyn

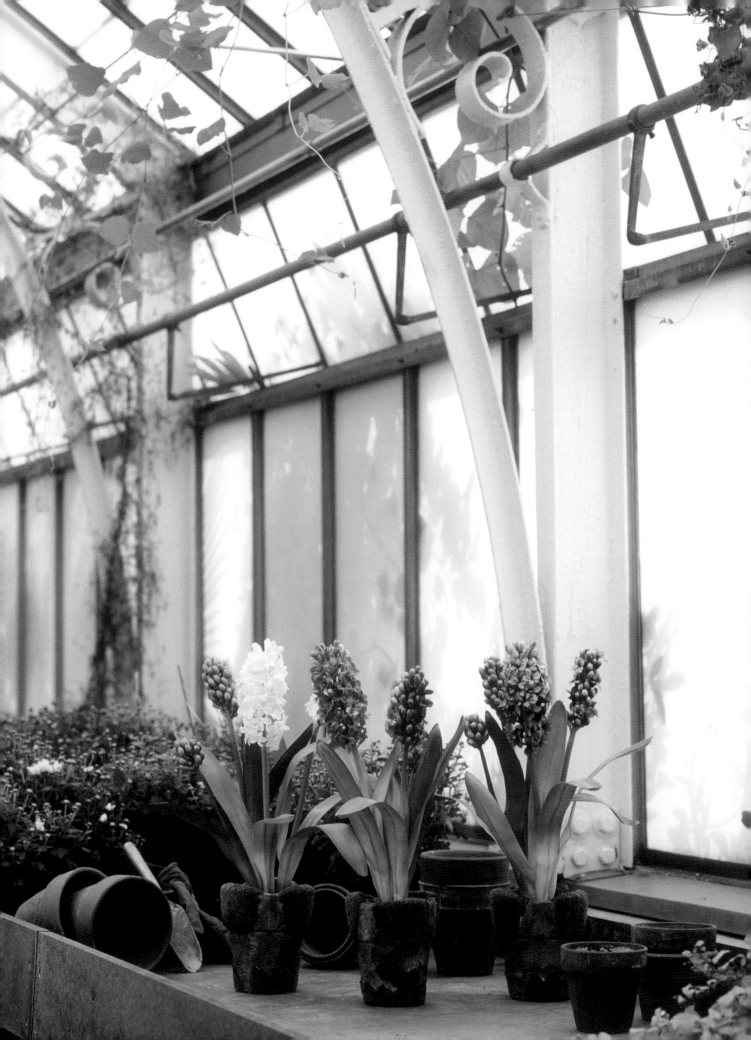

contents

introduction

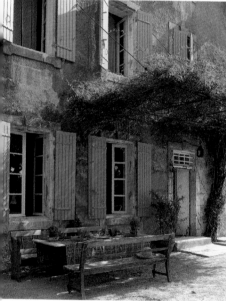

It's no great secret that when the weather is agreeable, our outdoor spaces become highly desirable living places. We, in fact, escape from our hermetically-sealed environments of artificial light and heat and air conditioners into the fresh air, the sun's warmth, the changing light of the day, the wind, the sound of birds' songs, and the fragrance of flowers. Even the smallest garden or balcony can offer a peaceful sanctuary in suburb or city. Be it there on a balcony or a patio, porch, terrace, or even an enclosed sunroom, we deliberately seek an intimate connection to nature in our daily lives. And we aspire to bring style and comfort to this natural extension of our home.

Our task is made easier today by the extensive options available. The bountiful outdoor decorating market does not exist by chance but by the accumulation of years of development by designers, manufacturers, gardeners, and horticulturists. Think, for example, of the invention of window films that control heat gain, allowing for a larger and larger expanse of glass. An interior room can now be open to the sun all year round with less concern for temperature control. We can easily control the heat in that room with shades and blinds. Furniture is much more weatherproof and, therefore, more durable, and is offered in a greater variety of outdoor types and styles. The commercial horticultural business has grown quite sophisticated; plants of all varieties are easily shipped around the globe. Landscape specialists are on hand to help the novice gardener. All this adds up to incredible choices.

In its design, an outdoor room can be whatever you want it to be—a totally green garden space, a room for entertaining and relaxing, or a delightful combination. Whichever your choice, it is bound to be a rich tapestry of color and texture and light and shade. Like the interior of your home, this is your personal space and can be as peaceful and tranquil—or as lively—as you like. Its elements will fluctuate more with the seasons than an indoor room, and that will bring pleasure and surprise. Simply put, an outdoor living space may end up touching all the senses and the emotions on several levels—and could end up being your favorite room in the house.

Outdoor Decorating and Style Guide examines outdoor rooms as an extension of your indoor space. Your outdoor room may already exist—a wraparound front porch, a wooden deck, a stone paved patio, or a formal loggia outlined by a classical row of columns—and may just need some redecorating. Or you may wish to add a conservatory to your property and fill it with tropical plants, or hire an architect and add a sunroom to your house. Whatever your needs, *Outdoor Decorating and Style Guide* provides inspiration and design ideas.

Outdoor Decorating and Style Guide shows how the traditional elements of design—space, mass, color, line, light, shade, and texture—are actively called into play when creating an outdoor room, just as they are when designing an interior space. This is not a book on horticulture, although it provides some basic horticultural tips. (The science of

plants is much too complicated to be thoroughly covered here. For detailed information, consult an expert gardener in your climatic zone.) Outdoor rooms, however, are inevitably softened with foliage, and planting should be considered as one major element of the overall design.

This quick introduction to space planning offers a basic orientation for how to view and use your outdoor space. Designing an outdoor room is essentially the same as indoors, except that outdoor decoration involves the unique integration of natural and man-made elements. You start with what is offered naturally—plants, soil, rocks, water, and air. You add wood, brick, concrete, metal, and glass. As you combine these elements, you strive for a delicate balance of scale and proportion, accent and contrast, and rhythm and motion.

The first section of *Outdoor Decorating and Style Guide* offers an overview of the varied resources available and special techniques that can be used in designing your outdoor room.

The style of an outdoor room is a matter of personal choice and may or may not match that of the house's interior and exterior design. Purists would have you match material for material, stroke for stroke, between outside and in. And such treatment—say modern-style furniture set against a sleek modern façade—can be beautiful. For many of us, our style choices generally define the overall aesthetic mood, such as classical, romantic, exotic, or playful. And, generally, connections between interior and exterior or between the architectural style of the house and the outdoor room are sought. Yet, in the end, style is a matter of personal taste. The definitions of style used here are meant to expand, rather than limit, your expectations.

For your outdoor room, establish style and mood with the choice of materials and decorative elements. Be it Mediterranean, or rustic, or romantic, the purer your vision, the more evident the mood. For example, think of a room's flooring material. Paving can be stone, flagstone, or traditional brick laid to set a formal tone. Teak, cedar, or outdoor wood bring a more rustic ambience. Mosaic tiles conjure the Mediterranean, while stepping stones in gravel resemble a tranquil Japanese Zen setting.

Strive for a minimalist, sleek, and elegant modern look. Or go more classical, with wrought iron furniture, symmetrically placed around a small fountain. There are many other choices in between—the romantic, the whimsical, and the exotic, to name a few. In the second section of *Outdoor Decorating and Style Guide,* acquaint yourself with different styles and moods in generic terms.

In the long run, your choice of style will be personal—and may, in fact, be a combination of genres. For the moment, let your imagination soar.

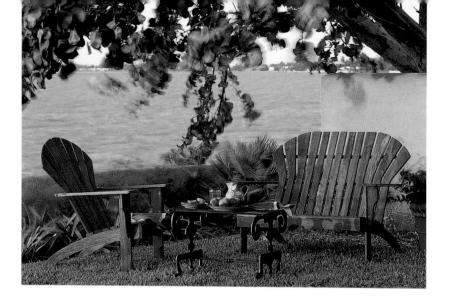

CHAPTER ONE

DECORATING
OUTDOORS

There is a popular adage—as concise as the simplest of recipes and beloved by both contemporary architects and landscapers—that an ideal domestic environment is composed of one-half house and one-half garden. This concept, an apt description of an outdoor room with its inherent desire to create a setting capable of artfully introducing man-made culture into nature, is certainly as old as design history itself. Ancient Egyptian houses often incorporated a loggia, a room walled only on three sides, built on the rooftop or facing into an open air courtyard. Spanish *alacazars,* the great fortified castles constructed during the fourteenth and fifteenth centuries, also face inward, turning away from public life, to focus on enormous, unenclosed spaces called patios. And dating as far back as the days of the Roman Empire, villas and palaces have been built to emphasize interior gardens, terraces, and atria that open to the sky. The writer Brendan Gill, a wry and gifted commentator on all things architectural, once remarked that R. M. Schindler, one of the twentieth century's great modernist innovators, "was a Roman in the mastery with which he wove indoors and outdoors into a seamless fabric."

An outdoor room is an enduring and complex source of delight—a haven that comfortingly reminds us of where we are while arousing a wondrous sense of escape.

above
An Adirondack chair and bench cast a striking portrait against the sea. The Adirondack chairs are stained rather than painted, for a rustic look. The decorative flourishes of the table's design, however, dresses up the composition. The stage is set for tea.

right
White cushions on metal furniture placed in classical symmetry bring a refined elegance to this outdoor room. Its motif is reinforced by the classical statue and fountain. The tall, slim Cyprus trees form a natural border for the room.

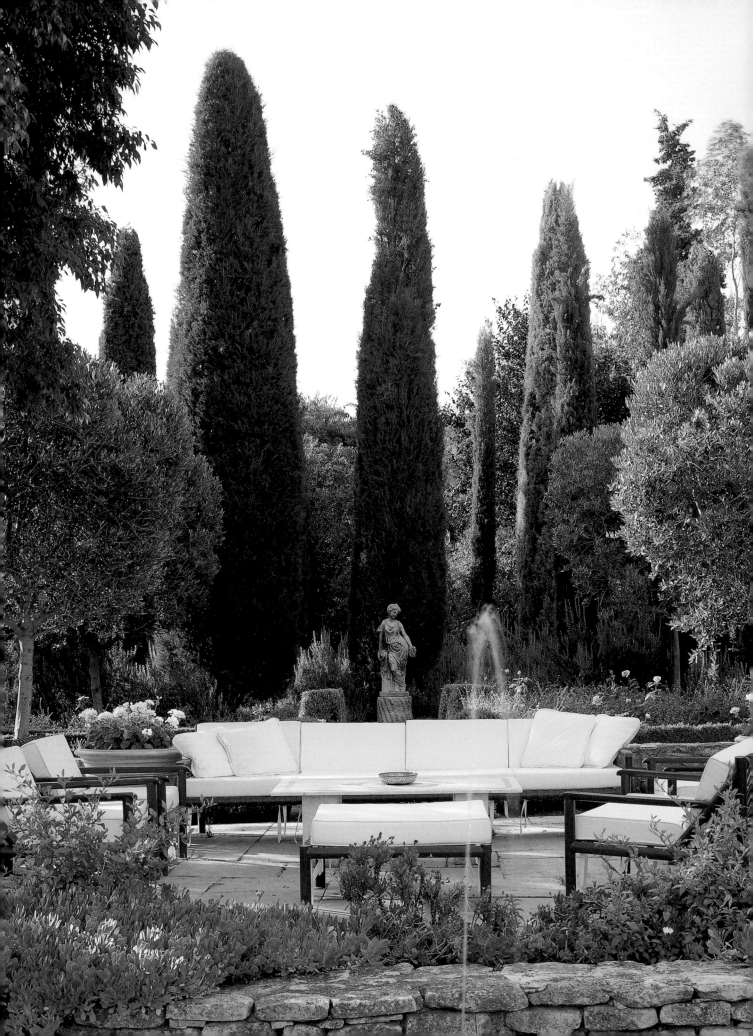

DREAM ROOMS IN THE OPEN AIR

An outdoor room may be the essential, site-specific work of art: an inhabitable installation that exists entirely in situ and nowhere else. It can be a room without walls, a space defined entirely by a floor plan marked out in earth, wood, rocks, grass, concrete, stone, carpet, asphalt, tile, brick, or wood. The boundaries indicating an outdoor room are astoundingly variable; the cloistered gardens of antiquity were outlined by architectural colonnades, shaded walkways that distinctly framed an interior, open-air courtyard, known as a *peristyle*. The landscaped space of a contemporary garden room, however, might be delineated only by a hedgerow, the concrete deck surrounding a swimming pool, or an old wool carpet placed over a fresh carpet of grass.

Out of doors, a room no longer needs to conform to the basic interior construction formula that requires four walls, a floor, and a ceiling. A room, by dictionary definition, is essentially an open space intended to be occupied. Once an outdoor space has been delineated—by placing a table and chairs out on the lawn, a wide wooden swing suspended in a shaded verandah, a quilt-strewn bed surprisingly tucked beneath a garden wall—a room suddenly awaits us.

Unlike their indoor counterparts, outdoor room designs don't always have to be linked to inflexible function. A terrace or a patio can often switch-hit as a free agent, a charming chameleon that might easily be reconfigured to serve as a dining room, an unenclosed parlor, an alfresco office, or a second kitchen. When we talk about designing for open-air spaces and the ineffable allure of creating a room within a view, can we say that the sky is the limit?

An outdoor room might be architecturally sited right at your own front door—a rambling, wraparound porch, a formidable Italianate piazza, a tiled courtyard entryway complete with a fountain. Or it can be in your own backyard: a plain wooden deck, a stone-paved patio, a formal loggia with a classical row of columns, a glass-paned greenhouse vibrant with tropical vegetation. These are living spaces that exist beguilingly between public and private, providing shelter and openness, and tempting the imagination to envision a retreat without ever straying from home.

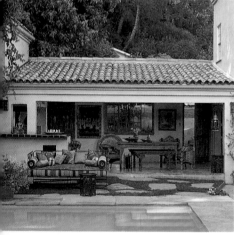

top
A daybed, invitingly piled with pillows, provides a tempting spot to get lost in a book or a daydream.

bottom
A kitchen, housed in an open-air pavilion, faces out poolside. A patchwork pattern of tufted grass and stone marks out the floor plan for a gracious outdoor entertaining area.

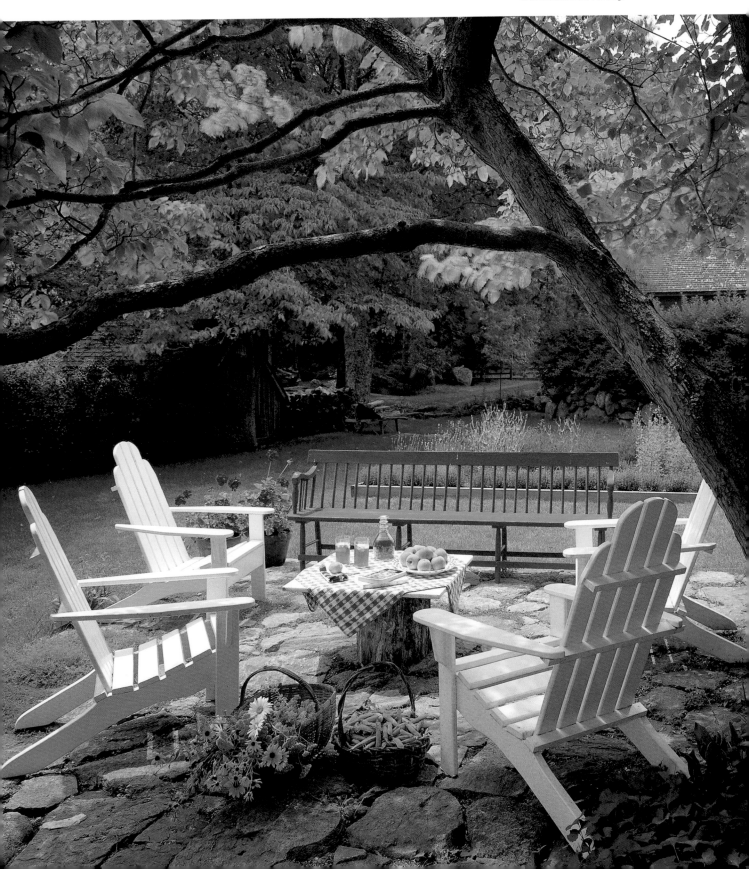

A quartet of classic white Adirondack chairs creates a dining area between house and garden. A red bench provides a border and delivers a bright contrast to the verdant surroundings.

The traditional elements of design—space, mass, color, line, light, shade, and texture—are all actively called into play when creating an outdoor room. In a completely open-air space, with only the sky for a ceiling, creating an outdoor room becomes as challenging as composing on a blank canvas. Strong colors, which might overwhelm a small room with an abundance of architectural detail, stand out brilliantly against the vast canvas of open sky. When furniture is placed out of doors, it often takes on a more definitive, almost sculptural quality. The outlined forms of container plants, furniture, and such standard room accessories as lamps and vases will appear more clearly in open spaces. A round dining table and market umbrella provide welcome contrast to the rectangular lines of a rooftop deck, and a long, sleek, modern couch, upholstered in bright white, stands out sharply against a voluptuous landscape of dark green.

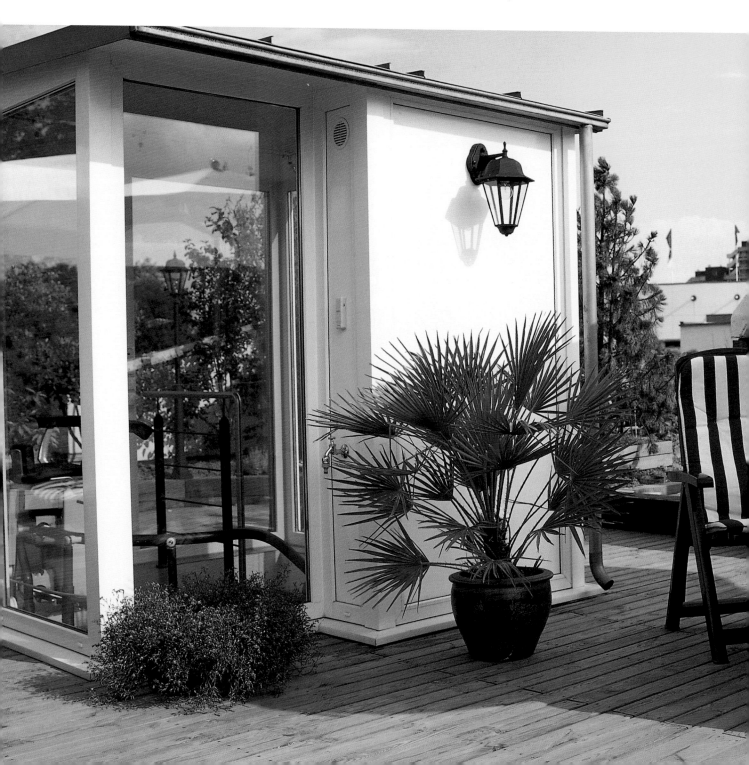

distinction in a cityscape

On a city rooftop, a deck—where diligent plants bloom under the watchful eyes of neighboring buildings—can provide a welcome respite from the pressures of everyday life. Bright colors and bold patterns—a pair of chairs decked out in wide stripes, a brilliant gold tablecloth—hold their own against expanses of sky and whitewashed walls. Working with a neutral palette of plaster walls and natural wood floors, intense colors and shapes stand out dramatically. A potted fan palm creates an exuberant silhouette against a stark background; an overflowing pot of purple flowers provides another invigorating dash of color. The strong natural sunlight is filtered through a canvas market umbrella. At night, a lantern illuminates the glass box entryway that houses the interior staircase and frames the view. Seated at the circular dining table, a guest can enjoy a meal and the dynamic panorama of urban architecture and distant hills.

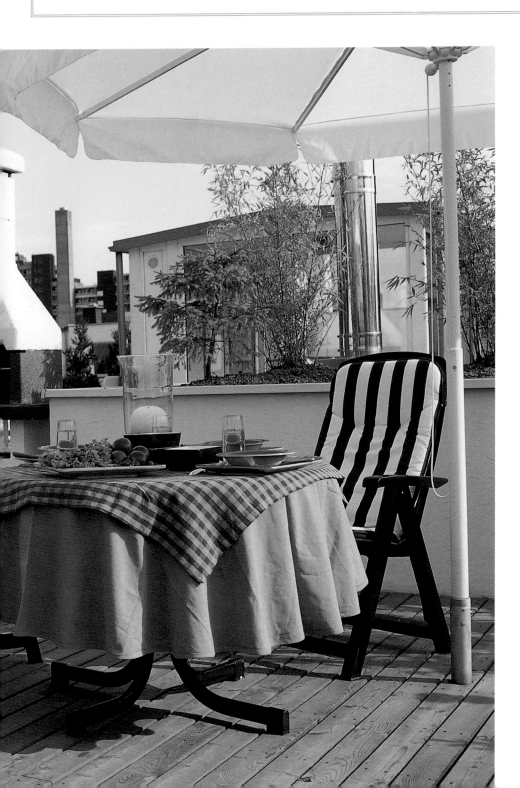

styles to consider

Creating an outdoor room can stir dreams and conjure up fantasies; it is an invitation to escape, to slip out of the conventional house and invent an alternative design for living. An outdoor room can offer the seclusion and sanctuary of a secret garden or throw open the doors for boundless entertaining. The variety of outdoor rooms traverses eras and cultures: consider the delirious moonlit trysts in the garden of Mozart's *Don Giovanni* or the plaintive doo-wop longing for the peacefulness in the city that exists "up on the roof."

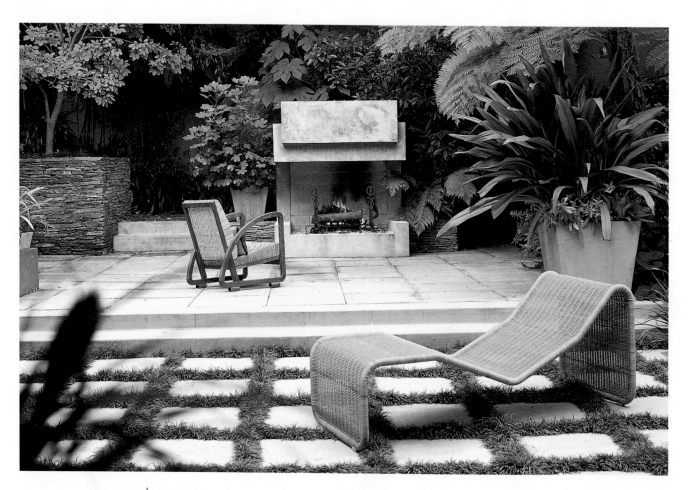

modern

A distinctly unfussy open-air patio, precisely marked out in a grid of tufted grass and square paving stones, is an ultrarefined, minimalist space. Each carefully selected decorative element—the spare, arcing chaise, a deep bentwood armchair, and the open, cubed fireplace—is as exacting and singular in its design as a piece of formalist sculpture. This outdoor room exerts a sense of sublime geometry, a contemplative retreat entirely untethered from the regular indoor household. The overhanging branches of Australian fern trees provide a light, feathery, green contrast to the large expanses of grey stone and concrete used to construct the border walls and terracing.

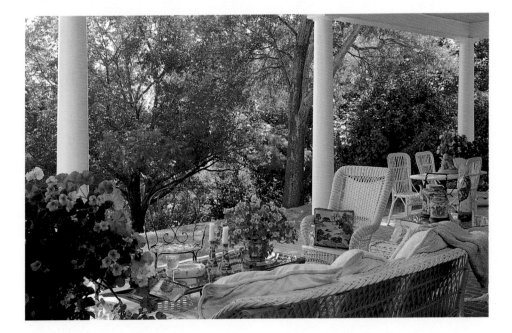

romantic

As a means of escape, an outdoor room offers endless destinations; the old-fashioned luxury of an endless summer afternoon, replete with creature comforts and a lush garden view, is captured in a colonnaded porch set with antique-style white wicker furniture. Daily life continues, at a slower pace, out of doors. Pillows cozy up a settee and a high-backed armchair; a glass of wine, a pair of candles, and a magazine are arranged on a low glass table, kept effortlessly close at hand to contribute to an atmosphere of sweet pampering.

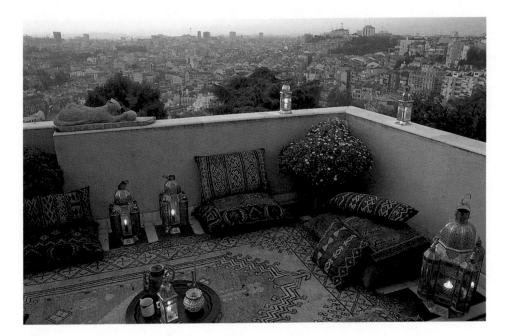

exotic

An oasis atop a city building invokes images of a thousand and one nights. The rooftop floor, covered with kilims and scattered with pillows, is solely intended for reclining beneath the open sky. Ornate brass lanterns cast a delicate, magical light. Potted plants are nestled against a low retaining wall. A simple circular tray, placed on the floor, serves as a table. Piles of pillows, in rich colors and intricate patterns, add a sense of luxury and intimacy. The rest of the city floats away.

DESIGN
BASICS

GETTING STARTED

Take a radical step today and look at your outdoor space with new eyes. Pull your favorite chair out onto the lawn, terrace, patio, or balcony. Remove everything else. (Or if you can't clear away heavy objects, pretend you have a clean slate.) Be patient. Observe the space at different times of the day. Imagine the activities you see taking place there—dinner with family or friends, a small cocktail party on a warm summer evening, quiet relaxation with a book. Start building the perimeters of the room; then add furniture piece by piece. Coordinate what other elements you may want, working down to specific, minute decorative accents. Think three-dimensionally. Consider the shifting outdoor environment and, ultimately, the rotating seasons. Your outdoor room should provide a rich tapestry of color and texture, light and shade, which fluctuates with the time of day and season of the year and is always a refreshing enclave of fresh air, changing winds and temperatures, and natural sights and sounds.

Not everyone will begin with a clean slate with every outdoor project. But it's a useful exercise to consider even when just redecorating. In your mind, clear away the clutter and start afresh. Why not consider, just for the moment, changing the size, shape, or placement of your outdoor room and its contents—or its personality?

The overall goal is to extend indoor living outside in a way that is highly livable—both comfortable and practical—but also lovely. Connect with nature in your own personal way. Create a truly unique place to relax, entertain, eat, or just escape.

SURVEYING THE TURF

To make the most of your outdoor space, you need to undertake two critical tasks. The first is to survey the property, taking stock of its strengths and weaknesses. Secondly, essential questions need to be asked about your own lifestyle, needs, and desires, and how you would like to utilize the space. Only then can you actually start planning the more intricate details that will create the mood and atmosphere of your outdoor room.

In an informal way, you've started the visual survey of the space on the preceding pages. Now it's time to dig a bit deeper and put pencil to paper. Start a preliminary drawing marking

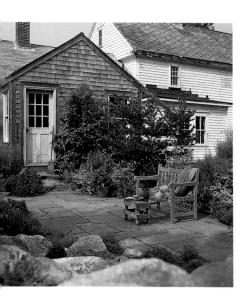

above
Clear the deck (or patio or terrace) and survey your outdoor room. Consider what changes you might like to make. Would you like to enlarge the space? Change the orientation? The materials? Add new furniture?

existing plants and spaces that you would like to retain. Notice sun and shade patterns, and if you can, how these patterns might change through the seasons. Determine which views are significant and if the desired vista is fully visible. Note how the site slopes and how level changes are handled—with stairs or just a sloped hill, for instance. Check for interesting natural features, such as rocks or a pond. You'll need to know the condition of your soil and your climatic requirements for planting purposes.

Also consider how your outdoor space looks from inside. And envision how it might look if redesigned. Then take out your tape measure and try to sketch the site, realizing that in the end, you may seek the help of a professional landscape architect, architect, or horticultur-alist, especially if you undertake a complicated renovation.

The goal is to determine the best use for the outdoor space. Typically, you can create several different rooms, unless, of course, your property is constricted on a small urban site. The second task helps you shape those rooms to closely respond to your needs. Question how each is going to be used and by whom. Think about transitions between rooms. Consider movement through the rooms. In the end, the success of the design may depend on how well the room works as much as how good it looks. Keep in mind that your budget concerns may affect your final design choices.

The twenty-one pertinent questions presented here are not inclusive but only meant to start the inquiry. Recognize that each home setting is unique, and of course, the use of an outdoor room depends on preference, but also on climate. Each location brings specific landscaping choices for outdoor rooms and different requirements for treating the natural elements, such as sun, shade, wind, and rain.

twenty-one questions

1. What outdoor space do you now use?
2. Who in your family uses it and for what purposes?
3. How often do you use it?
4. Do you consider it an outdoor room?
5. If you use the space for entertainment, do you find that it large enough for your requirements?
6. Is there is place to barbecue and dine?
7. Do you feel that your outdoor room is otherwise adequate, or could it be put to better use?
8. Are there other spaces that could become outdoor rooms?
9. Do you have easy access to the outdoor room from indoors?
10. Do you want to redesign the room or redecorate or both?
11. How much of the hardscape needs improvement—i.e., the paving, walkways, fences?
12. Is the landscaping in good shape or does it need some refreshing? Do you like to work in the garden?
13. If your room is a porch or gazebo or patio, do the walls or floors need improvement?
14. Do you need to do any electrical work around your outdoor room? Does this need upgrading?
15. How would you like to decorate your outdoor room—in what style: formal, romantic, exotic, minimal, eclectic?
16. Would you like to incorporate some of the elements you have now? What new elements would you like?
17. If you could have ten luxuries, what would they be?
18. Do you have enough privacy?
19. Is your lighting system adequate?
20. What is your budget?
21. What are some compromises to meet that budget?

ESTABLISHING BOUNDARIES

Establishing the boundaries of an outdoor room can be a daunting task. After all, we're accustomed to having the strict dimensions of our interior rooms preordained. Obviously, the dimensions of an attached front, wraparound, or side porch will already be set (unless you are adding on to your home). Designing these outdoor rooms will prove much more familiar to you than laying out a new patio or building a deck. For the latter you will need to have a keen sense of capacity from the beginning: How much and what size furniture will be there, and what other accessories, such as a barbeque or a fountain will be incorporated? How many people will the space accommodate? Building a deck to hold six is different from building a deck that can easily handle a party of fifty. Think about moving freely around the outdoor room, especially when it is decorated with furniture. Outdoor furniture can be a bit bulky, so take that into consideration. Draw plans with cutouts for the furniture, or use three-dimensional objects, such as cardboard boxes, to test your space planning.

Except for, perhaps, apartment and condominium living, most home sites offer the possibility of several outdoor rooms. These can usually be connected by pathways through gardened areas or can actually be one contiguous space, broken into separate areas. Think of creating focal points, as you would indoors, gathering places where people can congregate and provide an easy flow between the various "rooms." Room divisions are naturally created if the property slopes or changes levels and the shifts in grade are emphasized. Consider different personalities or styles for the various rooms.

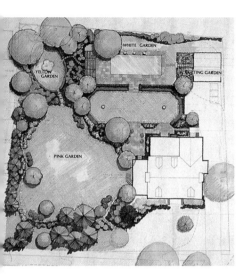

above
Putting pencil to paper: a landscape architect will develop a formal plan for your outdoor rooms. In the plan shown here the 10,000-square-foot house is actually a renovated horse barn. For its landscaping, the firm of Mahan Rykiel Associates, Inc., attempted to respect its rural site while creating spaces for entertaining. The new outdoor rooms include a pond, pool, deck, conservatory, and terrace; rose garden; and a large-scale chessboard/game terrace, as well as colorful gardens.

far right
This bird's-eye view reveals several different "rooms"—a bluestone terrace with trellis, a fenced-in flower garden, and a gravel-surfaced patio containing a metal table with a sun umbrella. For each, the boundaries are clearly identified.

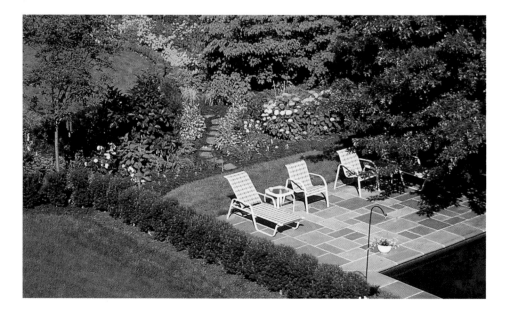

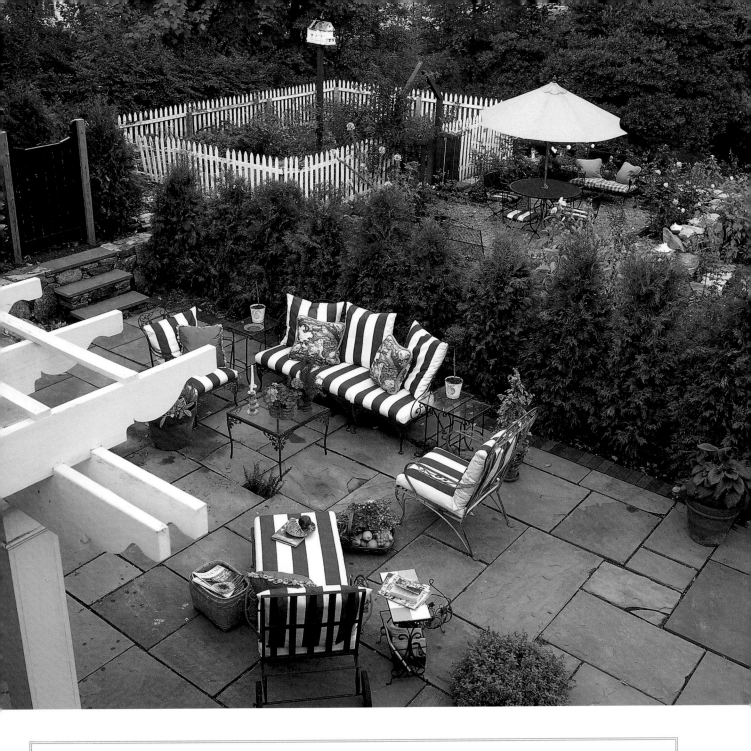

room/shape perceptions

- A square room draws attention to each corner, which in an outdoor room provides a somewhat rigid construction.

- In comparison, a circle stretches outward and creates a nonrestricted feeling.

- Breaking a space into different rooms can either make a small space seem larger or a large space seem more intimate.

- Rooms can be divided by planting, trellises, fences, hedging, or shifts in levels.

- Brickwork laid widthways across a narrow paved room will widen the space and laid lengthways, will elongate a room.

- Often a room will take an organic shape dictated by the preexisting contours or features, such as a meandering stream, a path, or a coastline.

basic design concepts

Outdoor rooms can assume many forms—porches, patios, terraces, gazebos, etc. (as discussed in Chapter Two). When designing an outdoor room, start as you would an interior space, with the structural foundation or the "bones" of the room. Examine the given—the walls, floor, and ceiling that exist, even if the ceiling is the sky! Consider changing the proportions and lines of the room. This is a simple, fundamental concept, but only if you think of the space as three-dimensional can you apply the basic principles of design, such as proportion, scale, balance, rhythm, and repetition. These, in turn, will produce a harmonious outdoor room—or if you like, one with a sense of discord, but planned dissonance.

proportion, balance, and scale

We seek a sense of balance and proportion for visual comfort. If that balance is missing on purpose, a designer can be making an explicit eclectic statement, intentionally drawing the viewer's eye to specific objects. More often than not, though, we're looking for a balance between the sizes of objects. So carefully select your decorative elements. Since we're looking for a balance between solids and voids, you need to think of your space in three-dimensional terms. If the elements in your outdoor room vary widely in scale, try grouping smaller pieces together to counterbalance one larger piece. Use landscaping and potted plants as balancing objects. Also try to think of the pieces of furniture as objects of sculpture. In that way, you'll focus on the particulars of a chair or table and make a conscious effort to seek good design. It's best not to overload your space with too many objects. You can always keep a supply of portable chairs nearby, for easy use when necessary.

It's often useful to use the grid of the house to help establish the layout proportions for an outdoor room. For example, if the façade of the house breaks equally into four windows, the distances between each could set the lines of your planning grid. Extend this grid out from the walls of the house and visually plan your outdoor room.

As outdoor rooms relate so closely to nature, often they take on organic shapes, so another visual clue can be an organic shape found in nature, such as the path of the brook in your backyard. Or sometimes the contours are simply modeled on a relaxed, flowing organic form. Often the shapes are repeating and even overlapping.

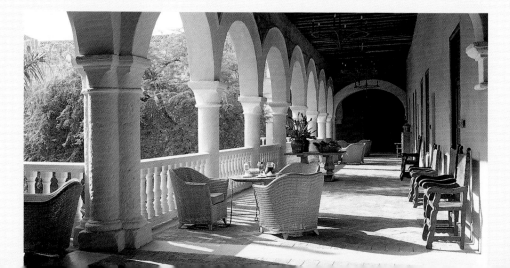

nature's framework

A huge range of plants is available commercially for gardeners. We usually consider them by commonly known categories such as trees, shrubs, bulbs, annuals, perennials, grasses, etc. For your outdoor room, plants may just be a decorative element, or foliage may provide structure or part of the framework for your space. If building a framework of plants, it's useful to consider categories established by the renowned British landscape designer John Brookes. He considers these the three-dimensional shapes of the horticulturalist's framework:

- The specials: the star performers that form focal points; a plant with a distinctive quality that allows it to stand out as a sculptural feature.

- The skeletons: the green background that will ensure year-round enclosure, provide a windscreen, and generally mold the garden space, or the bones, of a framework.

- The decoratives: the plants to be displayed in front of the skeleton.

- The pretties: the perennials for flower and foliage interest in spring and summer.

- The infill plantings: the transitory splashes of color as the seasons change and the invaluable gap fillers.

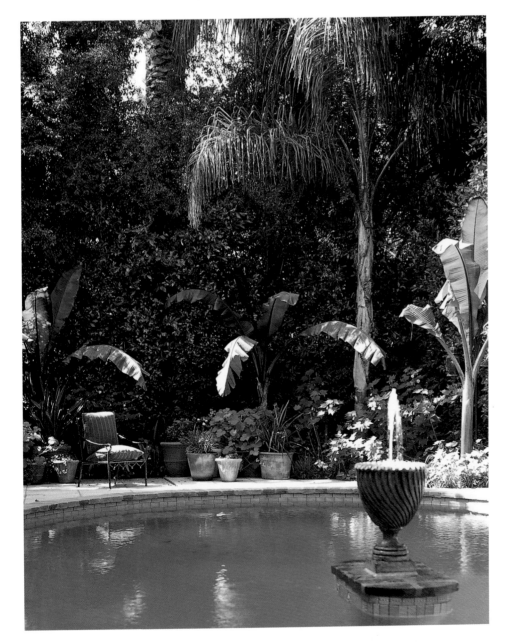

left
Exotic plants form a framework and act as focal points in this aquatic outdoor room. The red cushion adds more heat to the tropical climate.

far left
The view down this loggia shows a world in balance. The overall architecture, with its columns and arches, provides a consistent superstructure under which are placed groupings of wicker chairs and metal tables.

rhythm, repetition, and unity

When the design of a room—interior or exterior—seems visually pleasing it generates a sense of unity. Each element is strong in itself but together, they flow into a delightful three-dimensional composition. Tools to reach this unity are repetition and rhythm. Expert gardeners repeat certain plant colors, textures, and species throughout a garden to bring rhythm and unity. The same can be done with other decorative elements. Actually, when a certain style is chosen—say classical—some repetition is automatically built in. Most likely, you will choose a set of matching cast iron chairs to go with the glass-covered, cast iron table. The classical columns of the porch may be echoed in the side table pediment. What about adding a cast iron lounge rather than turning to teak? Your

pots may be pewter-colored rather than clay to continue the cool tonality.

In a more relaxed environment, repeat other materials or shapes, such as brick, wood, or fencing materials. Or develop an alternating pattern between two or more materials, which provides a sense of unity, in the paving, for instance. These contrasts can work, too, as long as there is an underlying sense of proportion and the effect is strong enough to provide real visual excitement.

If mixing styles is a preference, go for the eclectic look, but do so with some planned order or rhythm to your choices. Overall, strive for simplicity, for the understated is often more elegant than the overstated and cluttered.

right
Tucked beneath a rustic shelter is a casual daybed; its bulky horizontal shape is balanced by three square peephole windows set vertical in the wall above. Additionally, the bed is flanked by a rustic chair on one end and a collection of large pots on the other.

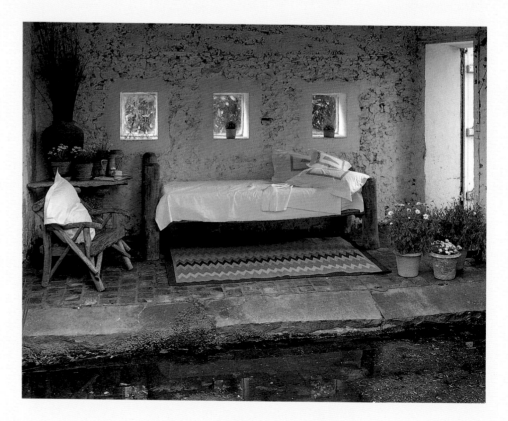

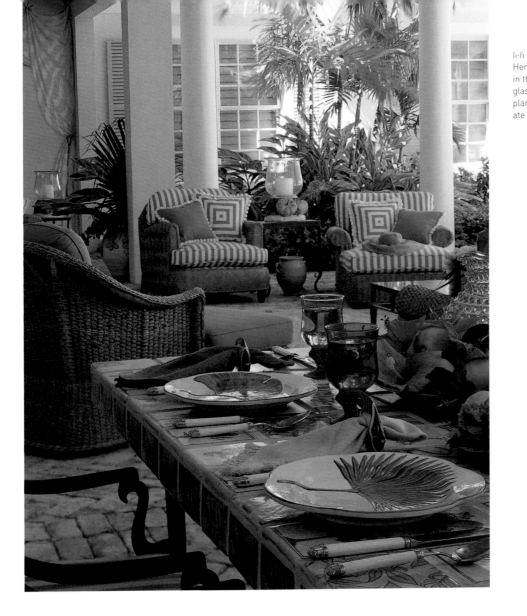

Here, the uniting color is blue, as found in the chair cushions and pillows and the glassware and napkin holders. The exotic plants behind the cushioned chairs create an edge for the room.

color promotes unity

Color can be the rhythm and repetition that establishes unity. The azure blue floor tiles of the terrace near the pool, for example, are echoed in the blue and white cushions that are reflected in the blue sky and the blue flowers in the vase on the glass table. That may be enough to hold the composition together.

Depending on location, colors used in outdoor rooms don't necessarily need to be flamboyant, but can, perhaps, be most pleasant when melding into the natural environment. Tans, grays, browns, greens, and the color of brick sit comfortably against outdoor materials. Remember, too, that nature's colors will change dramatically from one season to the next.

focal points and pathways

When arranging the furniture and objects in your outdoor room, it's useful to establish a focal point, a place where the human eye can focus and rest. For example, when guests enter, what do they focus on? The table set festively for dinner? A decorative swatch of fabric hung on the porch wall? A garden sculpture lit dramatically at night? A collection of exotic plants set in a group of container pots in the corner of the patio? Or the brightly-colored pillows arranged on your white wicker settee? Try organizing the rest of the outdoor room as a more tranquil three-dimensional composition around the chosen focal point.

Make sure there is easy access into and through the space. The entrances in and out should be clearly discernable. The flow through should be as smooth as it is in an indoor room. The issue of movement in an outdoor space clearly illustrates how important the planning process is— that one needs to keep in mind the rather bulky size of outdoor furniture and also how many people you expect the room to accommodate, at the maximum.

The pathways to your outdoor room are an important part of the design as they set the mood. Paths should be of a material that is compatible in color, texture, and mood with the outdoor room, but not necessarily identical. Entryways can merely hint at what is to be expected in the outdoor room.

For practical purposes, width should never be less than 3 feet. To gain a sense of unity, relate the lines of a path to the width of the existing doors or windows of the house. The path's shape—whether straight or curved—and the length will obviously depend on each individual design, but, again, the pathway's design should reinforce and introduce the overall theme of the outdoor room, or act as a transition from one room to another, by combining several materials.

right
Step out the French doors and up the stairs to the garden. The stone stairs complement the stone base of the conservatory and provide a gentle transition to the lush greenery. Potted plants add decoration.

steps and stairways: quick tips

Steps become an architectural feature when used to bridge dramatic changes in level. A gradual, slight and broad change in level can be used as a device to create separate rooms. When designing steps and stairways consider the following:

- Outdoor steps usually need a greater scale than indoor ones. In other words, you can be more generous with the design of outdoor steps.

- Generally, the higher each step is, the faster one goes up. Use steep steps to move up and down faster. A handrail may be necessary for safety on steep steps.

- Planting material will soften the edges of steep steps.

- The material used often dictates dimensions.

- Place emphasis on the steps leading to the front of the house. Take clues from the material and scale of the house's elevation.

- Different materials can be used for treads and risers. Keep the treads generous (no less than 12 to 14 inches).

- Create generous landings to break up long flights of steps.

- Shallow, slow steps can act as impromptu places to sit and rest—or to place potted plants.

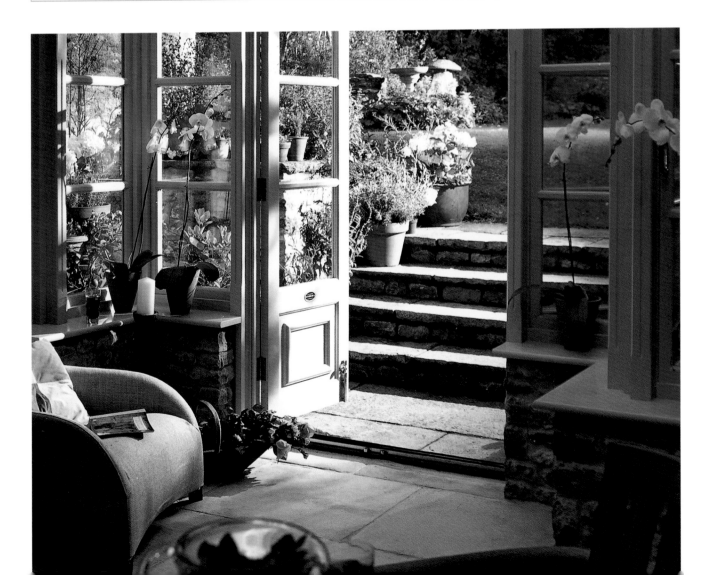

TAKING ADVANTAGE OF VISTAS

A fabulous vista puts a high price on a piece of property. A view out to the blue waters of the ocean or over the surrounding hillsides offers hours of pleasure. Yet, whether the view is quite this fantastic or not, every outdoor room should have a vista. It may be of the weeping cherry tree in one's backyard rather than the sun setting over the sea, yet that view may hold some promise—and be the only vista available. Try to take advantage of it. Rearrange it, if necessary.

First determine if there is a vista that is being obstructed—by overgrown vegetation, particularly—or one that is not in focus. When you discover your vista, orient your outdoor room to frame this view. Think of it as you would a beautiful picture, with the structure of the room being the frame, and examine the opening from many angles. Make sure the edges of the frame please you, or soften the frame with plants such as ivy. Reveal the whole vista at once, or conceal parts of it to be seen only from certain perspectives. You may actually see too much and may need to add trees or shrubs in the garden to provide a secondary frame of the view.

Or create your own. This will, obviously, take time. You'll need to plant a lovely, decorative tree, or find a dramatic piece of sculpture, or add a bubbling fountain. Or add a gazebo or trellis to the edge of your property. Invite birds, butterflies, or other wildlife onto your property.

Don't let the vista disappear on a moonless night. Throw some spotlights on it, if no other lighting exists, to at least bring some of the ambience alive. You may not be able to capture that distant vista but you may be able to hint at what is there and entice the viewer to come back at daybreak.

birds and butterflies

Invite the presence of wildlife into the boundaries of your outdoor room with a few simple features. A small pond, waterfall, or fountain will attract birds, as will ornamental birdbaths, birdhouses, and/or birdfeeders. Invitations revolve around food. Hummingbirds and butterflies like nectar-producing flowers, such as lantana, impatiens, and zinnias. Hummingbirds also prefer red, pink, and orange flowers. Larger birds desire plants with winter berries, fruits, and seed heads, such as crabapple, dogwood, elaeagnus, and firethorn. An inch-deep container of water is best for birds and butterflies. Keep the water clean. The splashing sound of water will attract more birds. Overhanging branches out of reach of cats and dogs provide secure perches for birds.

below
The table is set for dinner for four at dusk on the balcony terrace, under the trellis, with a dramatic city view in the background.

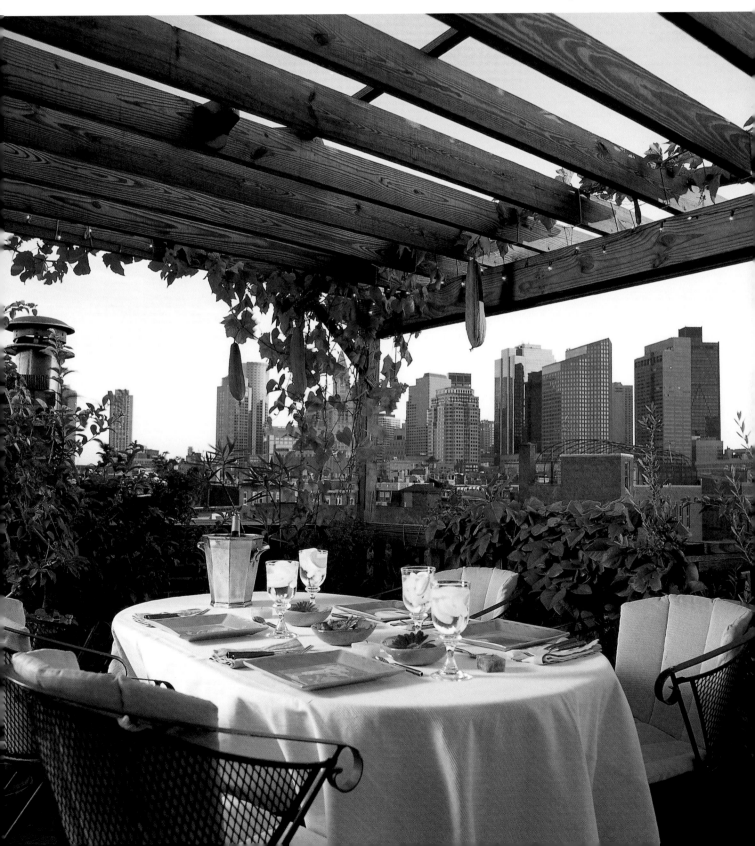

LANDSCAPE—HARD VERSUS SOFT

Outdoor decorating involves a balance between hardscape and softscape. Here, a patio created by Classical Flagstones is softened with potted plants and edged with grass, and made lighter by the presence of a weeping willow tree, under which the table is set.

Discuss your outdoor room plans with a landscape architect and the terms *hardscape* and *softscape* will come up quickly, unless, perhaps, you are designing a sunroom or conservatory. As the term implies, hardscape includes all the "hard" materials—the paving, wall, and ceiling surfaces, structures, furniture, etc. The softscape is the foliage. Balance between the two is the key objective. Of course, the experts will have their own opinions of what the perfect proportion is. The stonemason will inevitably suggest a larger stone wall than the landscape designer would.

Actually, a large part of the pleasure of having an outdoor room is the connection with nature. So, when choosing your furniture—and the rest of your hardscape—you need to consider the nature—or softscape—around you. Balance the size and bulk of your furniture with the greenery, or at least consider what might grow in your garden. Foliage can provide abundant color, texture, and fragrance. Plants can focus views, provide privacy, cool down hot summer days, shelter from winds, and attract wildlife. Plants grow, bloom, change color, and mature. The garden is never static and can be a source of great pleasure.

Encyclopedias chronicle plant species that are appropriate for specific climatic zones. If you are truly a beginner, it may be useful, however, to simply survey what plants exist on your site and then think about what might make the outdoor room more attractive. Start with deciduous shade trees and work down in size to smaller decorative trees. Evergreens are popular because they maintain their foliage year-round. Shrubs are considered foundation plants since they often define the overall shape and limits of a garden. Roses, of course, are international favorites, and are available in a wide variety of species. Garden beds can be filled with perennials or annuals of an amazing variety. Vines trail over trellises and arches. And grass or other ground plants cover the lawn. Landscape architects strive for color year-round, depending on the climate. There has been great interest lately in planting foliage that is natural to a particular region. The novice gardener might also balk at the idea of tending a large green space, yet planting options exist that are low maintenance. For small terraces and patios, potted plants and flowers can go a long way toward adding some natural greenery. Consult your local nursery. Even well-trained gardeners may wish to consult their local nursery!

LANDSCAPE STYLE

Decorating styles can define the appearance of our outdoor rooms. You can, for instance, choose among the historical styles, such as the classical, De Stijl, Edwardian, Greek revival, International Style, Queen Anne, Renaissance, or Victorian, among many others. Or you can consider style in a less formal interpretation, such as modern, romantic, exotic, rustic, urbane, or eclectic. Perhaps, the strictly historical is easiest to define. Other characterizations become less surefooted and, in fact, often reflect the personality of the viewer and the design viewed—there may be several different interpretations for the same design.

And what does it mean to possess a sense of style? How do you know that the juxtapositions of materials and shapes, and colors produce a delightful arrangement? In other words, can one learn to be a pleasing stylist?

The sampling of styles here and in later chapters of *Outdoor Decorating and Style Guide* is meant to be provocative, not definitive. The best way to determine what style appeals most to you and how to style your outdoor room is to survey as many outdoor spaces as possible. And experiment. You can't ignore location, climate, setting, and the surrounding architecture. You can embellish what you have in any way that you like. Remember, though, that elegance often comes from simplicity—or at least a balance of elements.

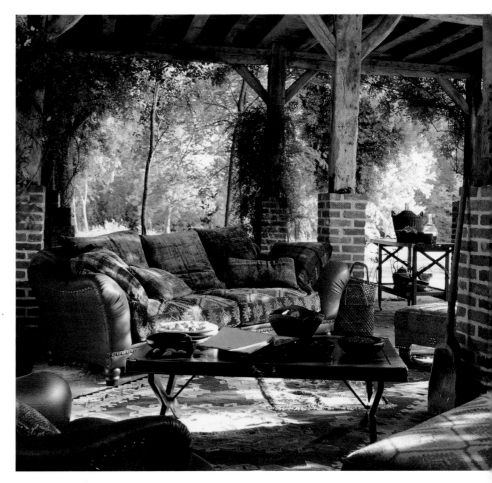

above
Rustic: Relax in luxury in the open air, while living the rustic, laid-back life. Under a rustic wood shelter, place a throw rug over brick floor to match the red leather sofa, covered with Indian print cushions. Rustic but chic.

THE OUTDOOR
ROOM

As a child, I was always delighted at the coming of warm weather in spring. We'd sweep off the porch, put the screens up, and drag the wrought iron furniture out of the basement. I'd have a new playroom where I could feel the fresh wind blow. I thought this very special. My elation deflated somewhat the first time I traveled south to visit Grandma and Grandpa, for I learned that in milder climates one could experience indoor/outdoor living year round. What an extraordinary luxury, I thought. Early on, I started to pay attention to the various forms of outdoor living, determined to incorporate several in my future home.

Eventually career opportunities took my husband and me east, a decidedly milder climate than the upper Midwest. We were determined to take advantage of the warmer breezes. And we have. At our modest brick colonial home, we've managed to include a deck, brick patio, hot tub, richly landscaped front and back gardens, tiny front stoop, and a sunroom. Our breakfast room is small, but has a cathedral ceiling, with floor-to-ceiling windows on two side walls. So, in warm weather, it's quite like a screened-in porch, and in cooler seasons, a sunroom.

If so much outdoor living can be enjoyed on a 40-foot by 100-foot urban lot, it can be found practically anywhere. The trick is to orient your house and property to accept natural light and the movement of fresh air. With natural light, usually comes a glimpse of nature— either gardens or treetops—at least some connection with the out-of-doors, and much brighter living.

The foundations for outdoor living may already exist on your property. It may just a matter of following the steps in Chapter One to discover them; others may ultimately wish to undertake major reconstruction. Besides determining what style you desire, it's prudent to review the outdoor living options available.

right
An outdoor dining veranda overlooks the luxurious pool. Vines growing up the columns of the veranda filter light and provide a natural barrier between dining and poolside—and between the bright light outdoors and the cooler, relaxing inner retreat.

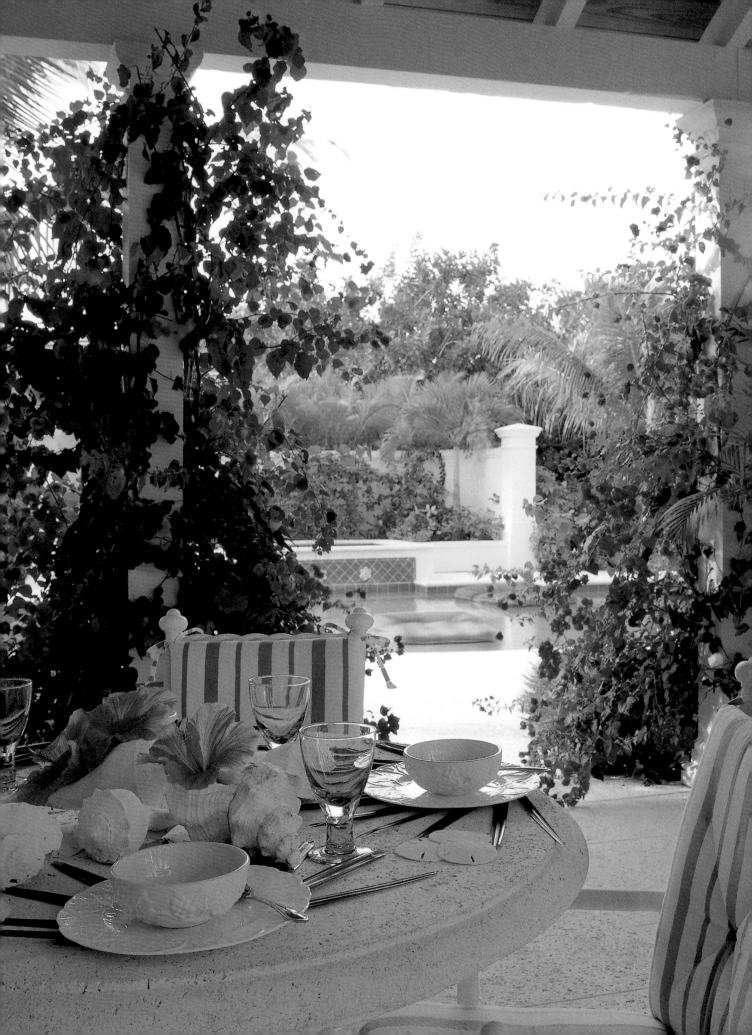

outdoor rooms

The vocabulary of outdoor rooms is quite extensive and includes the following:

ARBOR: A light, open structure of plants twined together and self-supporting or supported on a light latticework frame.

ARCH: A curved construction spanning an opening.

BALCONY: A protected platform on a building, supported from below, with a railing or balustrade.

BOWER: A sheltered structure in a garden.

CONSERVATORY: A glass-enclosed room for the cultivation and display of plants.

COURTYARD: An open area, partially or fully enclosed by buildings or other walls, adjacent to or within a house.

DECK: A flat, open platform.

ENTRYWAY: An entry passage.

GARDEN ROOM: The room in the house that presents itself to the garden.

GAZEBO: A summerhouse with a view.

LOGGIA: An arcaded or colonnaded porch or gallery attached to a larger structure, open on one or more sides.

ORANGERY: The original term for a conservatory.

PATIO: An outdoor area adjoining or enclosed by the walls or arcades of a house; often paved and shaded.

PERGOLA: A structure consisting of parallel colonnades supporting an open roof of girders and cross rafters.

PLAYHOUSE: A small structure for children's recreation.

PORCH: A structure attached to a building to shelter an entrance or to serve as a semienclosed space; usually roofed and generally open sided or glass enclosed.

POTTING SHED: A shed used for potting plants and other garden-support activities.

ROOFTOP TERRACE: A flat roof or a raised space or platform adjoining a building.

SUMMERHOUSE: A garden house of light airy design used in the summer for protection from the sun.

SUNROOM: A sunny room with a large expanse of glass.

TERRACE: A paved embankment with level top.

VERANDA: A covered porch or balcony, extending along the outside of a building, planned for summer leisure.

WRAPAROUND PORCH: A porch that wraps around two or more sides of a house.

SUMMERHOUSES TO GAZEBOS

Summerhouses and gazebos are favorites among those with vast land holdings—or at least with enough acreage to place a small structure far enough away from the main house for it to seem like a retreat. The word *gazebo*, in fact, means to gaze, and in the mid-nineteenth century it was first applied to various sized and shaped summerhouses built in far reaches of one's estate. While summerhouses are actually four-walled, miniature houses, gazebos are open and airy, with a solid roof supported by columns but no side walls. Gazebos provide shade and shelter, but allow warm breezes and the fragrances of the garden to flow through.

Both summerhouses and gazebos can be focal points. Summerhouses often serve the practical purpose to store garden or pool equipment, or become a secondary office space.

Gazebos are often Victorian in style, with gingerbread trim, and found in several different shapes—square, round, octagonal, and hexagonal. Materials can be wood, brick, wrought iron, with flooring of wood, brick, stone, or decorative tile. Traditionally, the design of a summerhouse echoes that of the main house, yet some take a bolder step and opt for a totally different style.

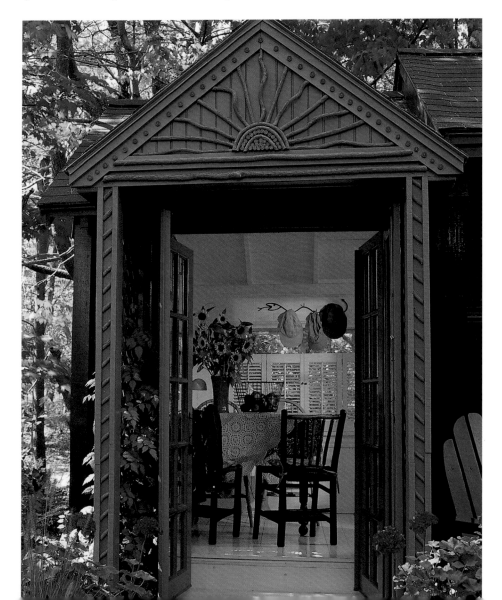

left
Distinguish your summerhouse with a quaint Victorian entrance. Such a handcrafted doorway with French doors warmly beckons visitors into your retreat.

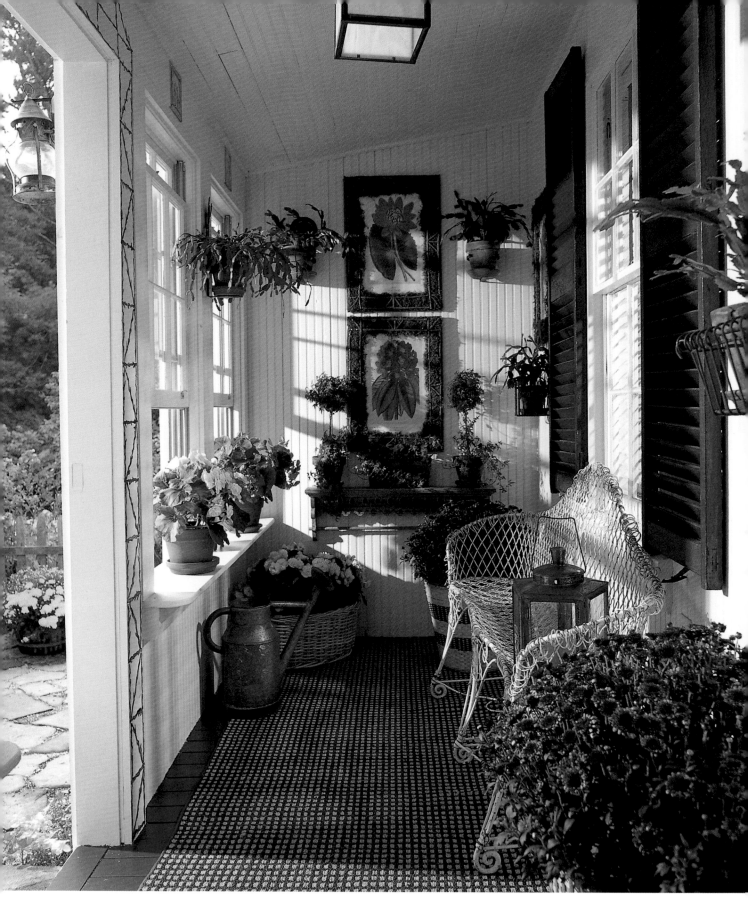

above
Filled with plants, this porch serves as a warm,
welcoming anteroom to the house.

PORCHES

The porch is an American institution. Many of the early home styles in the United States incorporated porches, be it a front, wraparound, or back porch. A basic construction, the roof continues down to extend outside the wall of the house and creates an open void space, which is further defined by columns and a railing. This can be a very congenial resting place or a play area for children. Most often, porches are an integral part of the architectural design; however, it is possible to alter the appearance of a house by adding a porch long after construction. In modern times, it has become popular to screen in or add glazing to porches. In fact, screening porches is an option that almost seems a necessity in a location that suffers from a high bug population in certain seasons of the year, like an oceanside cottage. When glazing is added, the porch may seem like a sunroom. The only difference may be that in a bona fide sunroom, every effort is made to bring as much natural light into the space as possible by adding skylights and expansive windows.

The front porch serves as a colorful anteroom, a place to first greet visitors as well as to watch passersby. Decorating options range from a simple welcoming wreath to a more elaborate arrangement of cushioned, wicker furniture. Wraparound porches can be split into several different rooms. One traditional function of the porch is to provide increase air flow into the house and offer a cool, shady outdoor space, particularly in temperate zones. Most builders recommend pressure-treated lumber because of the material's longevity. Ensure air flow beneath the porch and stairs to guard against moisture problems. Since some water will penetrate during hard rain storms, pitch the floor slightly away from the house so the water drains properly. Several other options exist for the flooring—ceramic tiles, slate, or granite. Generally, furniture should be weather resistant. Don't forget the traditional wooden porch swing.

cutting loose on the back porch

The main surface to decorate in a porch is, obviously, the wall or walls of the house—no matter if the porch is located in the front, back, or is a wraparound. Most likely the surfaces of the back porch hold the greatest promise for creative decorating, as you probably don't want to alter the surfaces of the other porches for aesthetic reasons. In the privacy of your home, however, have fun and head for the rear. Try hanging fabric on the wall to add a flash of color—or even a tradition painting. Or be even more daring and create a *trompe l'oeil* design (see page 89). Or you may just wish to get a can of paint and a paintbrush and some stencils. Paint is inexpensive and can easily be changed, when your mood changes.

ORANGERIES TO CONSERVATORIES TO SUNROOMS

Painted green, with transparent windows, and filled with plants, this conservatory virtually disappears into its lush setting at the height of the summer season. Notice the carefully composed paving transition from inside to outside.

Conservatories and sunrooms are enticing for those of us in regions where we can't be outdoors all year round. These structures allow us to bring the outdoors in.

Originally called "orangeries," conservatories appeared in the mid-sixteenth century in Europe when the aristocratic class began savoring exotic plants and fruit trees, especially orange trees. By the Victorian era, advances in the manufacture of glass led to the immense glass palaces like the Great Conservatory at Chatsworth in Derbyshire, by Sir Joseph Paxton.

Conservatories are still a popular as an adjunct to a home for the basic purpose of growing plants. Yet, modern-day usage goes far beyond, to include many more multipurpose activities. Currently, several companies manufacture conservatory kits, which can be simply added to your living space. Fully heated and air conditioned, these spaces are the historical precedent to the modern-day sunroom. The sunroom, however, is a much more integral part of a house design, the tracery of the glazing bars giving way to solid walls. But, like the conservatory, the sunroom aims to open the interiors to as much natural light as possible.

In the energy-conscious days of the 1970s, sunrooms and conservatories were heralded as marvels of efficiency. The design concept was for solar heat to be absorbed by the floor material, then slowly released at night, thus naturally supplementing the mechanical climatic controls. When no extra heat was necessary, blinds were pulled over the glass. Some designs went so far as having special solar collectors beneath the floor. What survived from those explorative times was the desire for a strong dose of natural light, the ability to control it, and the connection such glazing offers with the surrounding natural environment. Sunrooms and conservatories bring the garden inside, and also allow the viewer to practically be outside when within. In other words, several optical illusions go on at once; you feel you are in the garden even on the coldest or hottest or rainiest day.

When decorating a conservatory or sunroom, there's no need to worry about weather-resistant furniture or accessories, except to remember that fabrics will fade quickly in the constant, bright sun. It is, therefore, necessary to install blinds or shade, or in some cases, the room may be naturally shaded in the summer by large deciduous trees. The look of wicker, rattan, or cast iron furniture is appealing. When decorating the sunroom or conservatory, consider the romantic mood it takes on as the sun sets and the interior lights reflect off the extensive window glazing.

all the colors of the rainbow

How do you determine the color of those utilitarian outbuildings, such as garages, tool sheds, or potting sheds? Often the buildings themselves are quite nondescript and are built in neutral tones or wood, brick, or stone. Every once in a while, however, the outbuilding on your property might have some charm to it, and if it is wood or wood trimmed, you might wish to add some color to it. What do various tonalities do visually?

Over the years, I've experimented with the quaint, small garage that sits on my property. It's a typical building for the 1940s when garages were built on the alleys in the back of houses. It barely holds a compact car, and in fact, my husband now uses it as a woodworking shop.

When we moved in, it was painted a creamy color to match the trim of our red brick house. That seemed harmless and, in fact, was. The garage vanished into the alley, and we never really paid it much attention. I, however, thought it was quaint, and when we put an addition onto our house, decided to paint it a gray-blue with darker blue trim—like a Victorian beauty. I was very pleased, and all at once, THERE WAS A BUILDING OUT THERE. I loved it, but I'm not sure the neighbors did. The gray-blue didn't last long, for when we hired a professional landscape designer to redesign our front garden, she looked at the gray-blue trim on our brick house—and the garage—and said it had to go. It was apparently not, in her expert eyes, compatible with the planting scheme she had in mind. Now the shutters and garage are a dark forest green. And you know, as a background to our back patio and garden, I must admit, it works much better and looks lovely.

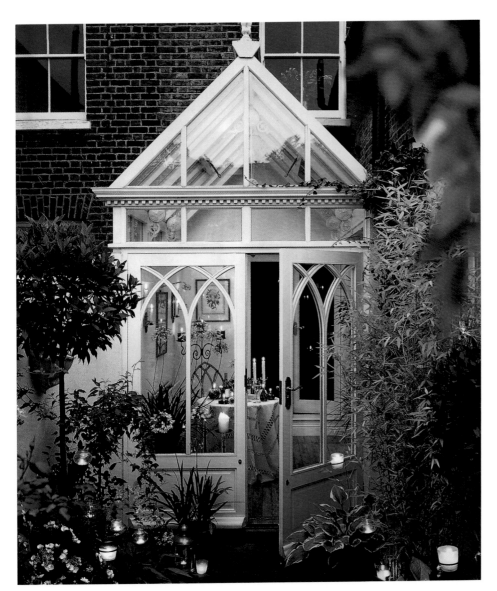

left
In an urban setting, a glassy anteroom lies in the narrow passage between house and garden. This custom-designed conservatory became a special all-purpose room and a romantic setting at night.

THE TRELLIS, ARCHWAY, ARBOR, AND PERGOLA

Create a sense of mass and height—and in effect, intimacy—in your outdoor room with the addition of a trellis, archway, arbor, or pergola. A simple structure, usually 8 or 10 feet high, it can be covered with one of a number of climbing plants and become a shady retreat in the middle of the hot summer. It can mark a point of entry or become in itself become the focal point of the room.

Pergolas had their origin in the vine-laden structures of ancient Egypt, which were built to carry climbing plants for both shade and food. The French and Dutch of the seventeenth century were particularly fond of arbored pathways or *berceaux*. Modern-day structures are made of tim-ber, brick, steel, or aluminum. The trick is to build the vertical supports wide and tall enough to support the climbing plants that will grow there. The 8 or 10 foot height might seem excessive when the plants are new, but remember that as the plants mature, the climbers will drape down. The result will be a pleasant shelter with dappled light, filled with fragrant and colorful vines.

For something different, try stretching fabric across your overhead structures, weaving it between the post and beams. This can provide a temporary shelter for entertainment, bring a splash of color to your outdoor room, and when lit at night, can add a touch of festivity.

right
A beautifully constructed pergola, its plan is actually quite simple. The posts are real Doric columns and the rafters are strong cross pieces with bold, notched endings.

far right
Passion plants *(Passiflora)* vie for position on the conservatory's glazing and will ultimately provide a thick green canopy.

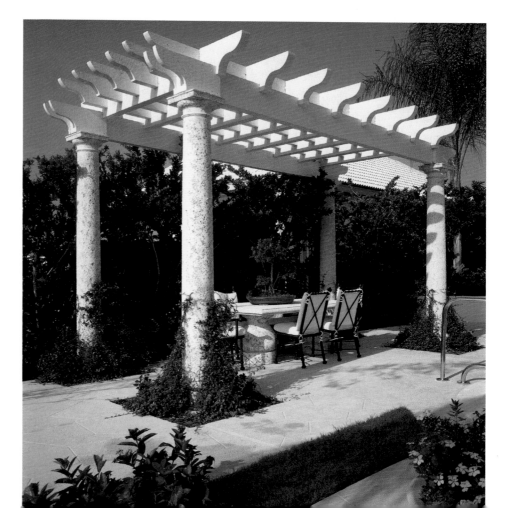

climbing plants for overhead structures

The woody and herbaceous climber is a versatile plant group that can add color and texture to the outdoor room. Climbing plants may be selfclinging or twining, or scrambling, or trailing. Clematis and *Passiflora* are grown primarily for the exquisite beauty of their flower. Others, such as *Lonicera periclymenum,* are valued for their fragrance.

If set on an open site, climbers on an overhead structure will be quite visible. The species of plant may, therefore, be chosen for the display desired at the time of day or the particular time of season. For example, if an arbor is used most often on summer evenings, it might be covered in common white jasmine (*Jasminum officinale*), *Lonicera periclymenum* "Graham Thomas," or the climbing rose, which have fragrant blooms in pale colors that show up well in the fading light. Large-leafed climbers, such as *Vitis coignetiae,* or *V. vinifera* "Purpurea" provide summer shade and turn a splendid fall color. A floral display of *Wisteria sinensis,* "Alba," in the spring is a favorite.

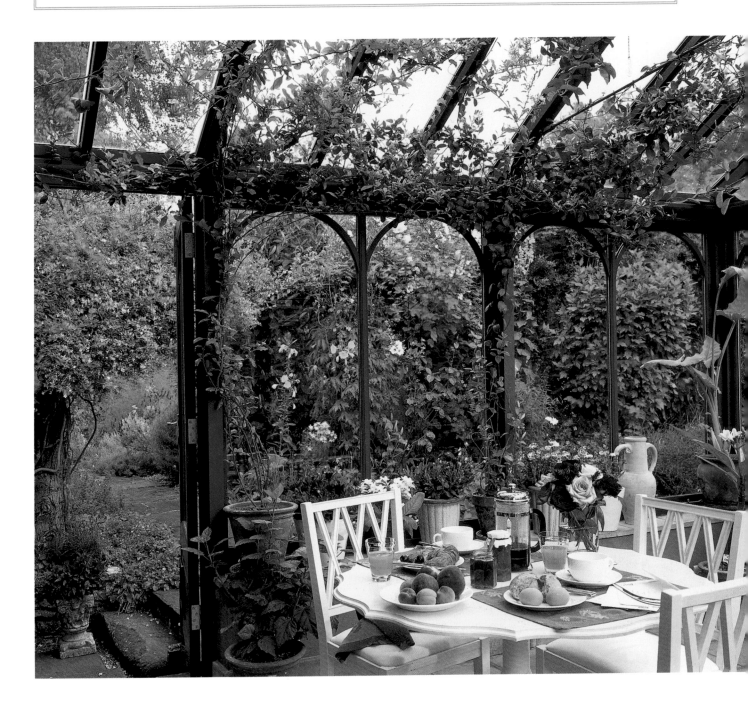

TERRACES AND PATIOS

Currently, terraces and patios are virtually synonymous, yet their derivations are historically different. *Patio* is the Spanish word for courtyard and refers to the open air, inner court found in early Spanish houses, and is used to describe parts of the Alhambra and the Generalife gardens in Granada, Spain. A terrace is generally a raised, level surface that extends from the rear of a house with a vertical or slightly sloping front. Both are now popular constructions to provide a hard surface on which to entertain, relax, play, and cook.

It's common for French doors to open onto a terrace, which is the same width as the living room or several rooms of the house. Sharing this geometry brings a sense of unity. Often located between the house and an elaborate garden, a terrace or patio can work nicely as

below
A bird's-eye view reveals the two rooms of this balcony terrace. Both contain casual teak furniture and are hidden from view by extensive greenery. The rooms are separated by an arbor trellis.

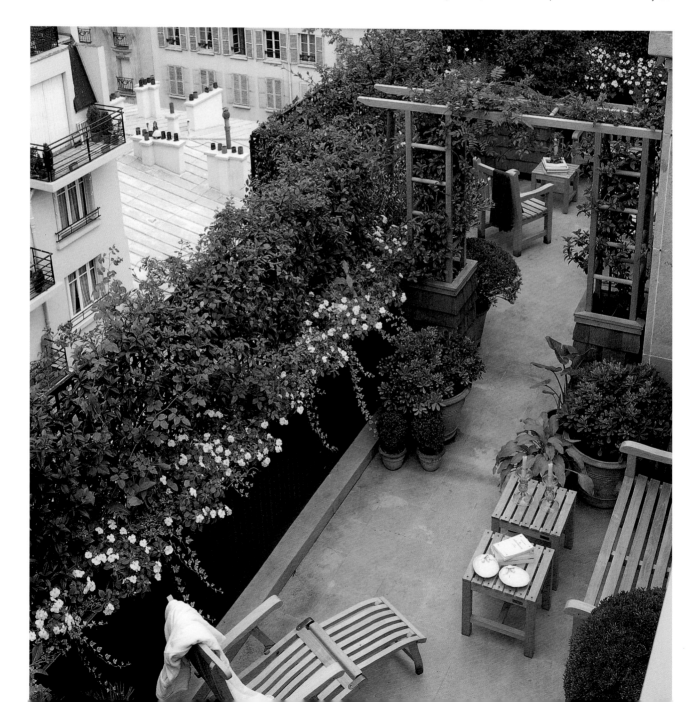

a transition space. Climate can influence location of a terrace of patio. In a temperate zone, a sunny and warm position is preferable. Shade can be added, if necessary by the addition of a deciduous tree or a pergola. In a hot climate, a shady position is desired.

A terrace or patio simply consists of paving material placed atop a poured concrete slab or a bed of clean packed sand. Often the main attraction is the pattern of paving—be it symmetrical or asymmetrical—or the combination of materials. The addition of sculptural elements, such as container pots, can provide definition. Planting around the paving can add color and texture and soften the hard edges. Consider a slight slope away from the house to allow for water drainage. And, if possible, multiple, tiered terraces can result in an interesting composition.

balconies and roof terraces: quick tips

These are private retreats that offer a great view of a city skyline.

For a roof terrace:

- Know the load-bearing capacity of the roof. Soil containers are heavy, as is the weight of furniture and people. You'll need to know much weight you can ultimately put on the roof.

- Make sure the roof area is securely fenced off.

- If the roof is exposed, you'll need to consider windbreaks, such as a trellis, wire mesh, fence, or plants.

- A sun umbrella can offer shade, but make sure it is securely fashioned to the roof's surface.

- Loose pea gravel or decking makes a nice floor surface.

- Consider plants that respond well to cliff-top conditions, as they must be able to cope with strong, drying winds, and hot sun. Try seaside and Mediterranean plant species in lightweight containers.

For a balcony:

- Make sure the balcony is easily accessible from inside.

- The balcony may be an extension of the inside room, and can be decorated in a similar manner through its similar flooring, furniture, and accessories.

- Flat-backed containers (rather than round pots) will fit neatly along the edge of the balcony and save space on a small balcony.

- Hang containers on the walls to save space.

- For privacy, put screens on the balcony's sides.

- To make a narrow balcony seem wider, run boards across it rather than down the length.

THE BACKYARD DECK

The use of wooden decks has become very popular in the last fifty years due to the advances in weatherproofing lumber. The concept originated in the early 1900s with the American oceanside boardwalk. Decks are a useful outdoor extension of the house particularly to bridge an uneven site or to float over swampy low spots. Decking lumber is also very resilient and won't break up the way paving can if it isn't laid properly. Materials used are usually pressure-treated wood, cedar, and cypress. Various looks can be created by different running of the planks and different levels of decking. The deck can be trimmed or left without trim. And it is easy to add built-in benches that can be made more comfortable with cushions of all kinds. Because many of the details and patterns are custom and built-in, each deck is unique. The overall appearance is one of a clean, crisp surface.

Decorate your deck with built-in, wooden containers for plants. A deck is also an opportune location for a hot tub, which can be sunk into the decking. Deck supports also provide vertical hangers for potted plants. Lattice can provide vertical fencing material, if desired.

right
Use a wooden deck to elevate the surface above uneven ground, yet at the same time create a unified space. Here the decking material melds well with the architecture of this tropical retreat.

creating privacy

You have created your outdoor retreat and now you would like some privacy from the rest of the world—or at least the surrounding neighbors. You can plant a natural boundary of trees and hedges, but remember that maturation of the foliage will take a good two to four years before reaching the density to suit your privacy needs.

The closer we live together, of course, the more intense the need for privacy and, perhaps, the need for distinguishing boundaries. Solid wooden fences in a variety of heights and sizes are popular for suburban and urban sites. Open fencing made of wood or metal is also available, if somewhat less private. Historic urban neighborhoods may encourage the use of wrought iron or picket fences, depending on the location.

Solid walls can be made of any mineral rock types, but most commonly are brick, adobe, wood, or concrete. The chosen material—its color, size, and texture—often matches the architectural style of the surrounding buildings and the setting. It's important to envision the mass effect of the wall when built.

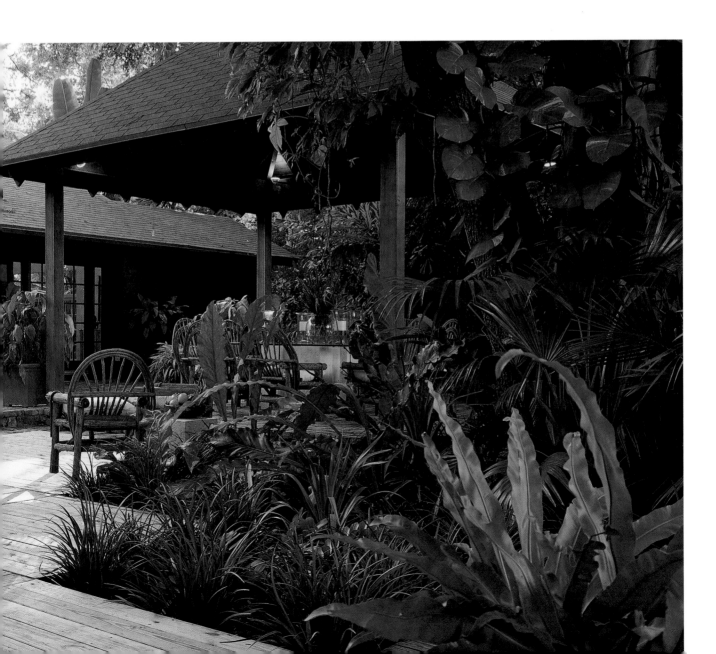

THE LOGGIA

The loggia is a less commonly known architectural feature that is being revived in warmer climates. It is defined as an arcaded or roofed gallery built into or projecting from the side of a building, especially one overlooking an open court. If the loggia is deep enough, it can be furnished, becoming a genuine outside room. In fact, the loggia becomes an extension of indoor living. If overhead heaters, lighting, or an open fire are added, the space can be used for many months of the year. In that case, the furnishings may take on a more permanent appearance than the usual outdoor pieces.

The loggia is a construction of antiquity. In ancient Egypt, houses often had a loggia on the roof for outdoor living with protection from the sun. In medieval and Renaissance Italy, the loggia was frequently connected to a public square. And at that time, it also became a central feature of a villa, a motif that has lasted throughout the centuries.

below
At night, when the shadows grow and spotlights and candles are lit, the mood on the loggia changes drastically. Now, it becomes a place of romance and intrigue.

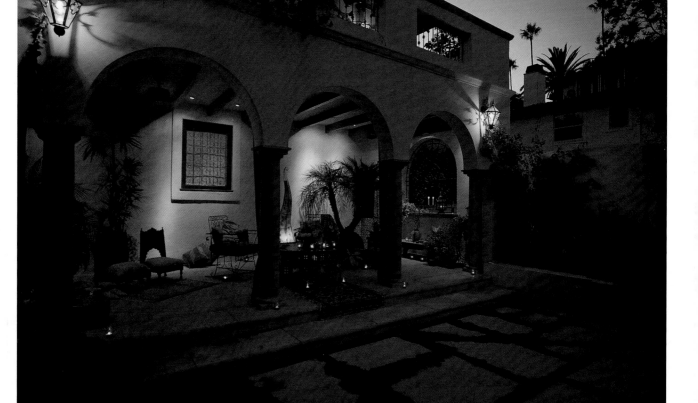

right
During the day, the sun illuminates the loggia, offering enough light for most of the activities taking place there. The mystery of the Turkish-style decorations is subtly displayed.

creating mood: day and night

The mood of an outdoor room shifts dramatically from day to night. Notice that when the sun begins to set and the lights come on, the space gains a sense of warmth and intimacy. In fact, the atmosphere of the room is constantly changing as the sun moves across the sky, particularly if that room is oriented to the east, south, or west. By late afternoon, in a west-facing space, some shade from a blind or shutters may be needed to diffuse the strong natural light. Then when the sun sets, open the blinds or shutters, light the candles and low-voltage lights, and enjoy the intimacy of the room against the darkened night.

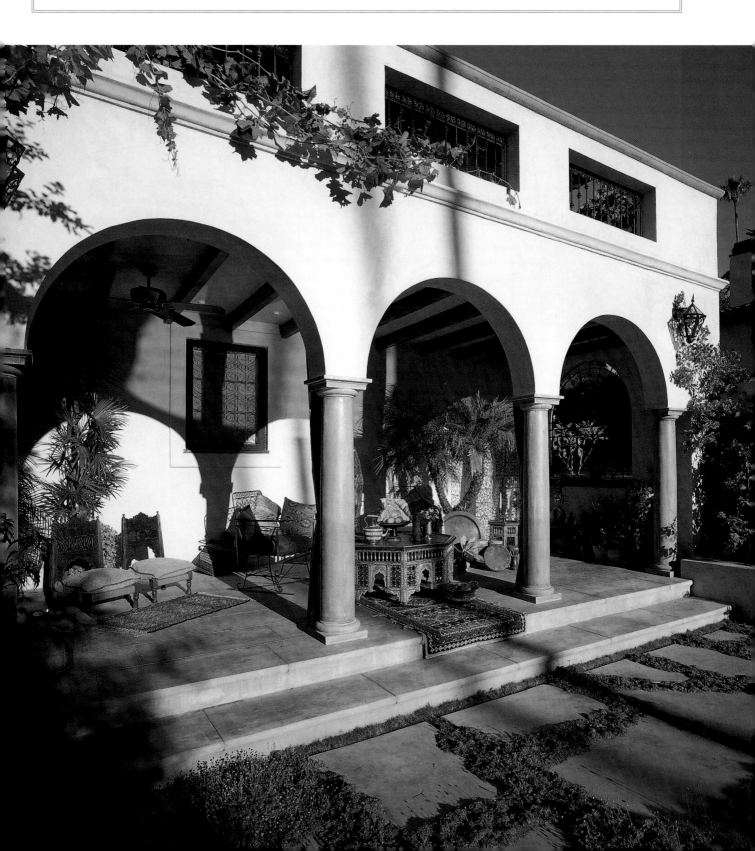

ESSENTIAL
ELEMENTS

The basic outline of your outdoor room is in place—be it a wraparound porch or backyard deck or brick patio. You've conferred with a landscape architect or various plant guides and have a general concept plan for your garden plot or potted greenery. Now its time to turn back to thoughts of aesthetics and style and consider what furniture and accessories will bring comfort to the outdoor room. Once again, you need to question your use of this outdoor space—is it for dining, entertaining, relaxation? What is the ultimate image that you envision? Reach beyond just the chairs and tables and consider paving, wall, and ceiling surfaces (if there are any). What decorative accents will enliven the space and heighten its mood and personality? An urn or a classical sculpture will bring a formality, while a colorful birdhouse will add some whimsy.

In earlier times, outdoor furniture often was quite rustic and made from materials on hand. For instance, Adirondack furniture originated in the middle of the nineteenth century in upstate New York. Made from roughly hewn and bent branches and logs, Adirondack chairs are fashioned with slats with a slant back and wide arms (excellent for setting drinks on). This style is often reproduced for garden furniture today. Yet, if you're not interested in the rustic, contemporary garden furniture covers all stylistic modes. The trend is toward weather-resistant materials that are lightweight and longlasting.

OUTDOOR FURNITURE

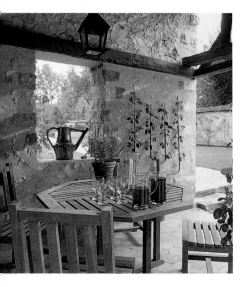

Mother Nature is tough on outdoor furniture. Constant exposure to sun, rain, wind, dirt, and, perhaps, cold weather, takes it toil even on the most rigorous of materials. Furniture manufacturers have responded by offering more weather-resistant products. The trend is toward more and more furniture that is often quite resilient for outdoor use and stylish enough for more permanent use indoors in sunrooms and conservatories. Yet even with the sturdiest of pieces, year-round exposure in cold climates will eventually lead to deterioration, so the objective is to make the furniture sufficiently portable to be pulled into storage when necessary. It is suggested that only the hardest of products, such as teak, remain out all season, particularly in inclement climates. Among other durable materials for outdoor furniture are metals (aluminum stands up best), plastics, glass, marble, tile, and cedar and redwood.

Perhaps wood blends in best with the natural environment. Teak is long-lasting and weathers best. If left outdoors, it will eventually take on a soft gray patina. Cedar and redwood also have the same high oil content as teak, which makes them more weather resistant than other woods. Other wood species can be protected by paints and stains.

Metal furniture, particularly wrought iron, brings a classic tone to the outdoor room. Often used with heavy cotton cushions or open-weave plastic seating and glass-top tables, metal also has the advantage of being visually lighter than wood. When purchasing metal furniture, make sure the surfaces are smooth, with no bubbles or weak spots. If the piece is collapsible aluminum, make certain the mechanism is durable and safe.

When choosing plastic, make sure the pieces are thick enough to stand up to heavy use, and that they have smooth joints. Plastic furniture can include fiberglass, Lucite, laminated plastic, polystyrene, polyvinyl, and acrylics. These are available in many styles and colors.

Regardless of the style you choose, some designers recommend that you consider each piece of furniture a piece of sculpture. That doesn't necessarily mean purchasing only expensive, one-of-a-kind, custom-designed furniture, but to carefully consider the shape, proportion, and lines of the chairs, tables, and chaises that you do choose.

Great strides have also been made in treating fabrics for outdoor use. Most fabrics for cushions use either polyester that has been treated with a vinyl coating or acrylic, and hold up well through increment weather.

teak

The use of teak in construction reaches back in India for more than 2,000 years. The name teak is from the Malayan word *tekka* and refers to the large deciduous verbena tree or its wood, *tectona grandis*. Native to Indian, Burma, and Thailand, it is an extremely durable species. Its naturally high oil content makes teak very stable when exposed to weather and temperature extremes. Teak resists rot, shrinking, warping, welling, and termite attack. It is smooth to the touch and does not splinter. In India and in Burma, beams of wood in good states of preservation are often found in buildings many centuries old, and teak beams have lasted in palaces and temples more than 1,000 years.

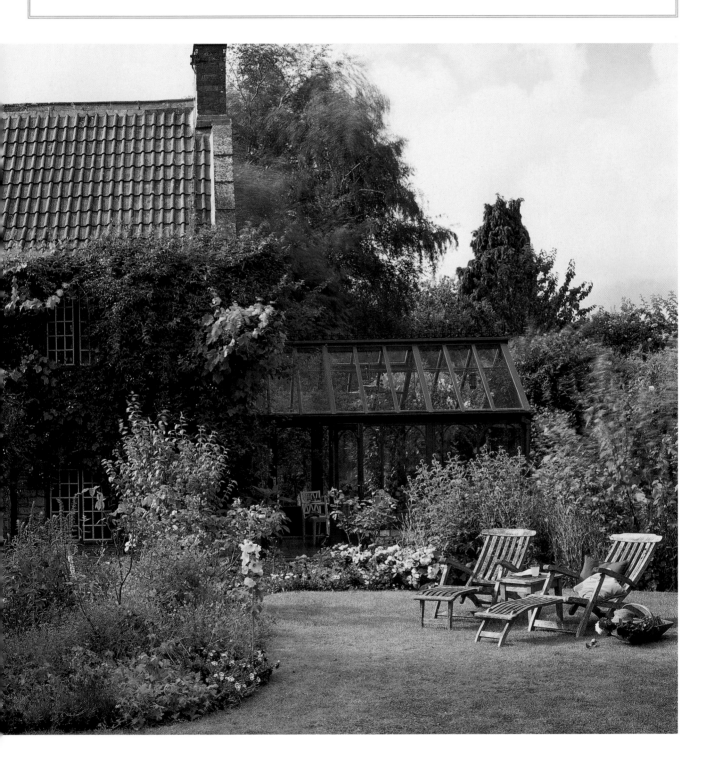

below
A stone hearth throws light and heat into the open-air room, extending its usage well into the cooler months. Sit near the hearth in wicker chairs, one of which is a rocker, and enjoy hours of cozy relaxation.

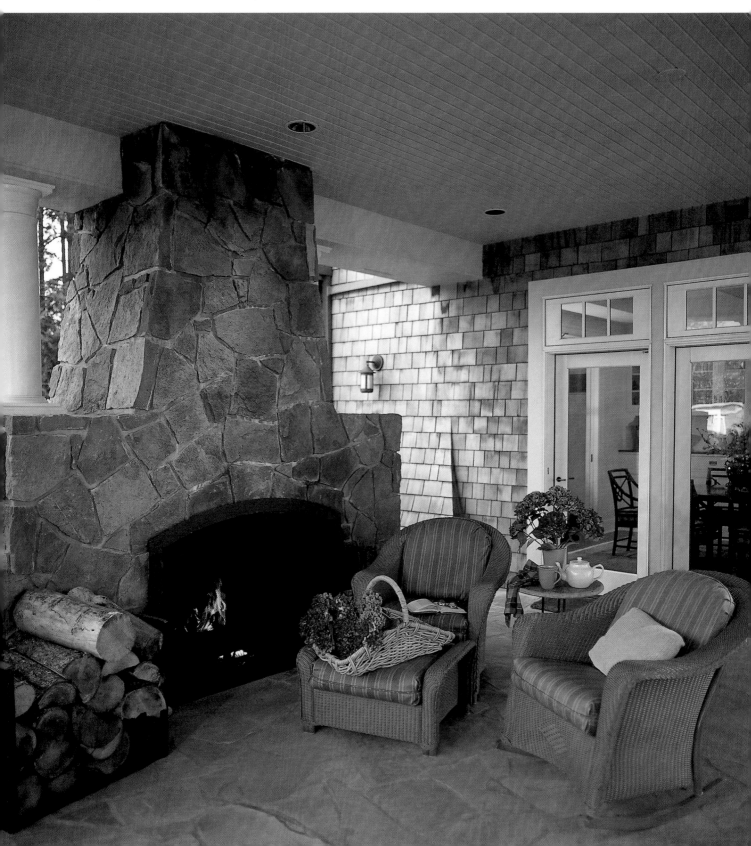

PROTECTED OUTDOOR FURNITURE

In your sunroom or even protected outdoor space such as an enclosed porch, you can arrange regular interior home furniture. Or you can decorate with outdoor furnishings to get that natural feeling, without the usual wear and tear. Obviously, in a sheltered environment, like a sunroom or conservatory, you won't have inclement weather to worry about, but you will have to consider sun damage. Regardless, don't hesitate to set up your favorite table and chairs or pillows. And, too, it's useful to keep a stock of foldable, stackable chairs in storage for those festivities when you need extra seating. Many outdoor tables are extendable. Plant stands can double as stools. The objective is to not crowd the outdoor room with excessive furniture. Extra pieces can be added on an as-needed basis. Keep your space open and flowing. Floral patterns bring a nice ambience to a sunroom.

For these protected outdoor spaces, wicker is the all-time favorite. Wicker is a catchall category that can also include cane, rattan, and bamboo. Wicker is a lovely, traditional material that is lightweight and can be painted or left natural will age gracefully. When purchasing wicker, make sure it is sturdily constructed and that the joints are bound well. Wicker has a tendency to shed, so check that there are not many "tails" apparent that will later unravel.

a blazing hearth

The evening is cool, yet you are warmed by the outdoor fireplace. Flickering ambers light the space and cast shadows on the massive, raised stone hearth. You sip coffee, content to sit and let hours pass.

Depending on the climatic zone, a fireplace can extend outdoor living far into the fall or through winter months. In the coldest, northern climates, it can be also a pleasure on cool summer evenings. Often attached to the main house, or perhaps to an outbuilding, the outdoor fireplace should contain the basic elements of an indoor one: a center firebox with a back wall that reflects the radiant energy of the fire outward, and a chimney that draws and lifts the smoke above the height of the roof. A decorative mantel, firebox, and/or raised hearth becomes a focal point and gives the outdoor space the intimacy of an indoor living room.

INTEGRATED FURNITURE

above
Cover a bench with foliage, or clip your shrub to resemble a bench.

Built-in benches and tables offer permanent furnishings of simple beauty that are inte-grated into the overall look of the outdoor room. A common place to find built-ins is the backyard wooden deck, where the furniture is simply an extension of the decking. The furniture is most often customdesigned with the deck.

Permanent pieces can also be made of marble or stone and set in the garden. Perhaps the stone wall edging your room can double as a sitting bench. Built-ins are also convenient additions to screened-in porches, gazebos, and pergolas, and can be decorated with bright cushions and pillows. The only disadvantage, obviously, is also an advantage of built-ins: they are permanent fixtures. One of the joyful experiences of outdoor living is that the environment can be easily changed from season to season and year to year. Built-ins obviously eliminate that possibility, but they can be adaptable in other ways. Use the benches as surfaces for other decorative elements, such as potted plants, or as serving areas when entertaining.

electricity

Electricity for your outdoor room is an important consideration in the planning stage. Will low-voltage lamps light the garden at night? Is electricity needed for a water pump for the fountain? Will there be power for a small refrigerator? The most integrated solution is to bury protected, armored cables at least 2 feet underground. A choice location is to dig trenches along the borders of an outdoor room, the boundaries of the garden, or the edges of the lawn. It's easiest to locate electrical outlets along the outside walls of the house. And it is convenient to locate switches for some lighting within the house, if possible. Laying electrical wires is a specialized and potentially dangerous activity; you may wish to seek professional help for installation.

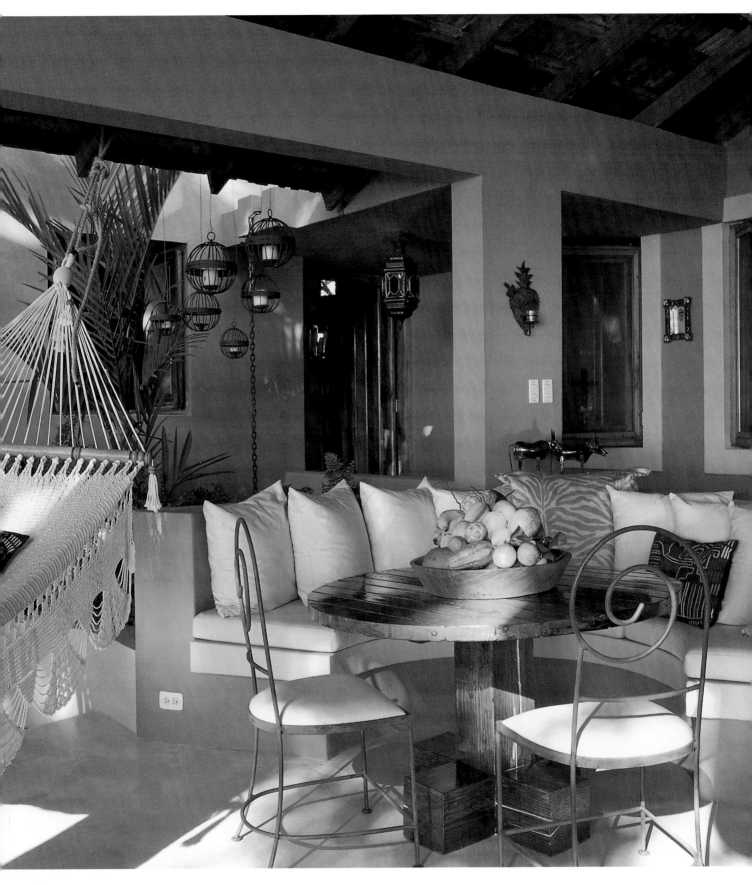

above
A built-in booth makes a cozy corner when piled high with soft pillows. A round wood table is pulled up to the built-in seating, as are two decorative café chairs, to make a pleasant seating arrangement.

PAVING

A decisive element in the design of outdoor rooms is the material used for the floor sur-
face—or the paving. A vast choice of natural and man-made paving materials can produce
different looks—and ultimately different moods. Line, shape, color, and texture are con-
siderations, as are stability and cost. Often one material, such as brick or flagstone, is the
dominant unit, with a secondary material as trim or accent. In a small paved area, it's
most aesthetically pleasing to keep the paving simple, using no more than two materials
and choosing a straightforward pattern. For larger surfaces, such as expansive terraces
and patios, interesting combinations and patterns juxtaposed against the softer, organic
qualities of planting can prove quite attractive.

The use of paving reaches back to antiquity. The Romans perfected the form of paving in
which gravel was simply embedded in the earth for stability and strength. The Romans
created a form of concrete. Later, the craftsmanship developed and brought elaborate
schemes and patterns, with finely worked stone, tiles, and brick. Currently, paving is laid
on a carefully prepared foundation or base. The foundation may be reinforced to support
excessive weight or simply be compacted sand. As with other decorative elements, straight
lines in paving produce a precise, formal appearance, while curved lines take on a more
informal look.

above
Create a mosaic floor pattern by creatively laying
pieces of stone.

design underfoot

Extensive paving options include:

- Brick: Usually set in sand, brick can be arranged in several different patterns, such as diagonal, herringbone, basket weave, or a simple running pattern, which can create a formal or informal effect. Manufactured bricks are dense and strong, do not absorb water, and are available in blue or purple-black. Handmade bricks are more porous, offering a softer look and surface texture and are red and pink-red in color.

- Stone: Introduces opulence and classical appeal to an outdoor room. Natural stone occurs in many different colors and surfaces, from limestone to granite, including flagstone (irregularly-sized stone), rubble or round pebbles, or ashlars. Gravel creates an effect like a carpet in that it smoothes out evenly.

- Tile and Mosaics: Especially useful in warm climates. Tiles and mosaics come in a vintage, old-world style, and are made of ceramics, cobbles, or glass, and can introduce strong colors and textures. They can be used sparingly as accents with slate and limestone.

- Concrete: A mixture of cement, sand, and aggregate (gravel), which, when combined with water, produces a thick liquid that can be poured into any shape and then dried. This makes it a very versatile material. It can also be dyed any color. The aggregate can be exposed, by washing or brushing away the fine concrete before it sets, to reveal the stone with. Pebbles can be added before the concrete dries to dress it up.

- Timber: Usually softwood that is pressure-treated with preservatives, used with hardwood structural supports. Where weight is restricted, timber can be a useful paving surface.

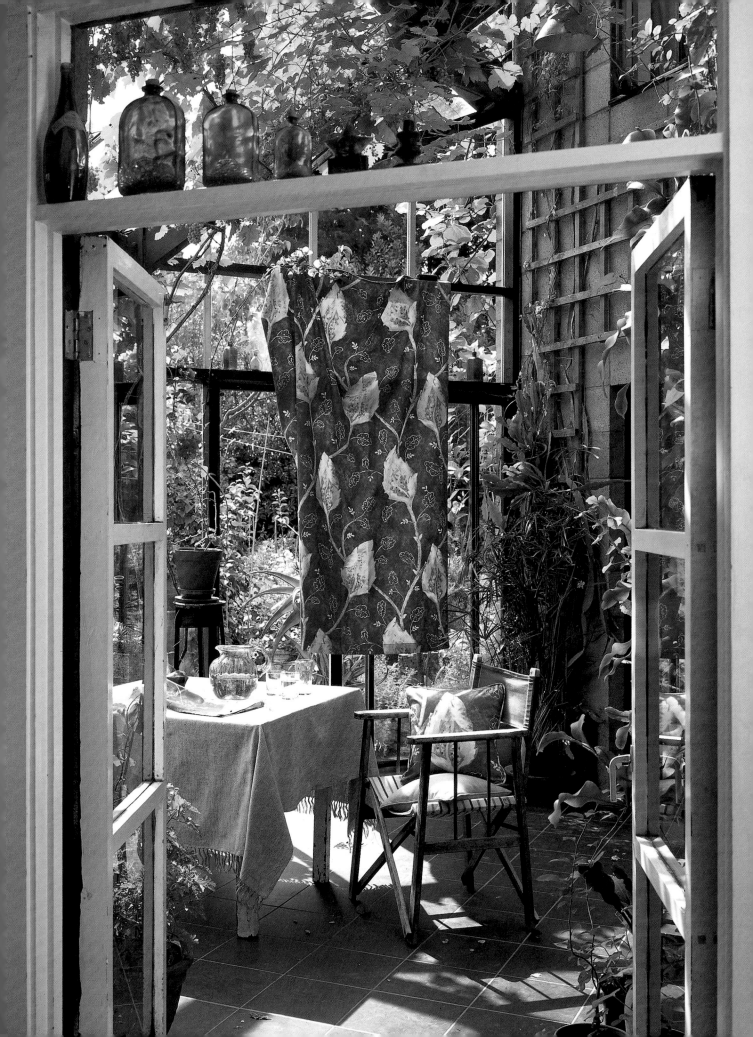

FABRIC

Enliven your outdoor room with swatches of fabric. Generally, the fabric will be used as chair or bench cushions or tablecloths (or flags!), but go a step further and hang a fabric panel from a doorway, along a wall, or from a trellis. Pay attention to the strength of the natural light. Bright colors may have more appeal in sunny, warm locations, and green and pastel in shady, cool areas. Look to nature for inspiration— the yellow-green glow of early tree buds in spring, or the purple crocuses; the bright primary colors of summer flowers; or the golds and yellows of fall. Or try the colors of the sky at sunrise. Blue is a popular color by the ocean, sea, or poolside. Coordinate your scheme to match the seasons and keep it relatively simple—and change it as often as you like. Lightweight fabrics,

such as cotton and gauze may hang most freely; canvas will provide protection from the elements. Fabrics can bring a lot of variety, warmth, and atmosphere to your outdoor room.

For outside use, weather-resistant cushions offer bright colors and patterns. The current technology involves UV-protected, solution-dried acrylic fabric filled with a foam, poly, or fiber-fill core, which is meant to be quick drying, mildew resistant, and stain resistant.

Save the more delicate fabrics for the screened porch or sunroom. In fact, most fabrics are appropriate there. A word of caution: The strong sunlight will cause the colors to fade.

a matched perennial bed

Highlight the color of your fabrics in a small perennial bed. Nonwoody plants that live for two or more years, perennials offer a rich variety of shape, form, color, texture, and scent. Often valued most for their flowers, many also have attractive foliage, ranging from the ribbed, furling leaves of hostas, or the swordlike straps of iris, to the fine tracery of fennel. In general, the foliage outlasts the floral display, so seeking perennials that have ornamental leaves helps to extend the season of interest.

In fact, a sense of texture in a garden is most dramatically conveyed by the foliage (or the plant form). Consider how the plant's varying textures work together, and aim to set up contrasting groups so that they complement one another, almost as you do pieces of fabric—and also think about adding color: one, two, or several colors. Be daring and experimental, or subtle and restrained, and consider matching the color scheme you have already chosen for your outdoor room. Or provide a restful border of white, pale pink, cream and/or gray.

left
The bright light illuminates the gold leaves on the blue curtain. Hung as a decorative element in this garden room, the curtain's design motif is reflected in the chair pillows. The fabric acts as a shade device, controlling the amount of light entering the room.

WINKY'S KALEIDOSCOPE PORCH

Enamored by kaleidoscopes as a child, Winky Wilson-Colm displays that love of color and pattern in her screened-in porch. As she would say: the bolder, brighter, and more outrageous, the better.

An interior designer and antiques dealer, Winky sells wares at local antiques shows. Her porch is the repository of found objects and the works of her artist friends. For a renovated lean-to, Winky choose a Victorian theme, as a throwback to her childhood home in Memphis, Tennessee. In the renovation, she retained the thirty-year-old brick patio floor and added lattice work to the frame, which she painted to endure the heavy Oregon rains. She jazzed up the porch with trim—a set of Victorian-style corbels, which she spray-painted white and placed at the corners of each exterior section of the screen.

To complete the Victorian image, she furnished the porch with wicker furniture and a white Adirondack chair with vintage fabrics. And then she filled the shelves and table tops with the original artwork and whimsical collectibles. To finish the vibrant interior, one morning Winky decided to paint the names of the flowers in her garden around the porch beams. So she gathered her craft paints and brushes and set to work.

right
Step into Winky's porch and encounter a blast of color. An interior designer and antique dealer, Winky choose a Victorian theme for her outdoor room, and filled it with original artwork and collectibles. It's a visual delight, complete with names of the flowers growing in her garden stenciled on the porch beams.

far right
Winky carries the kaleidoscope outside in a hand painted bench, a brilliant design that features the sun. Motel-style chairs surround a festively decorated card table. Bright colors are the palette of the day.

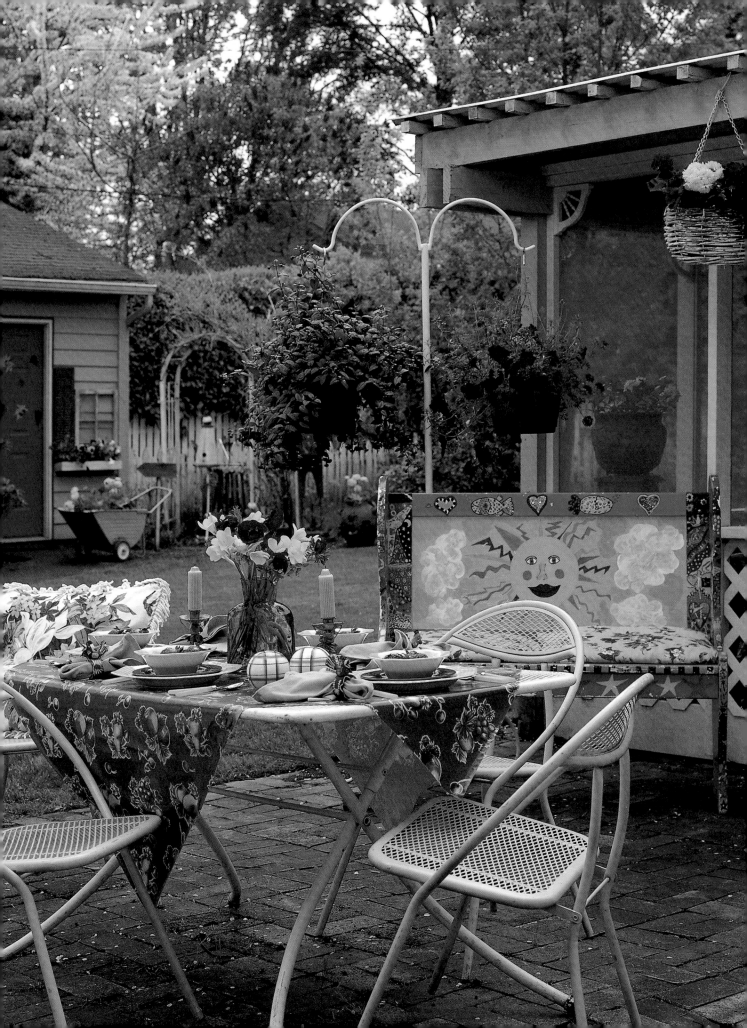

DECORATIVE ELEMENTS

What and how many decorative accents to include in an outdoor room is a highly personal preference. Sculpture and other artworks can add an element of surprise. You can choose pieces that link indoors to outdoors. Or you can choose decorative accents that are decidedly made for outdoors—birdbaths, birdhouses, and wind chimes. Found objects can bring an eclectic flavor, while all types of pots and containers add a colorful touch.

Outdoor spaces can be showrooms displaying your favorite art. And that art can be abstract or classical sculpture, found objects, or even pieces of furniture. Visit the great public sculptural garden museums for inspiration. Either the entire space can be a gallery, or the artwork can be a focal point. Lighting becomes an essential ingredient, as the art should be quite visible at night. The artistic object could be the surprise element in your outdoor room.

Consider what artwork, if any, you would like to hang it in your screened in porch or in your sunroom. And, while you are at it, think of all the decorative value of all materials around you—the ceilings, flooring, and walls. How those surfaces are finished will affect the long-term enjoyment of the outdoor room.

Exotic plants, either planted in the ground or in planters, can provide drama. After all, the more exotic are usually more difficult to grow, so you might as well show off your horticultural skills. At night, the shapes of the plants will be more distinctive spotlighted against a blank, hard wall surface.

When choosing objects, scale is perhaps most important, particularly if the decorative element is going to be a focal point, such as a piece of sculpture. Consider mass as well as size. Simplicity and harmony with the other design elements are key considerations. The repetition of some elements will add to a sense of unity. Adequate lighting is a necessity and can play an important role in mood setting.

left and right
Choose from an array of decorative options. Strive for simplicity and harmony among design elements.

arranging pots

Make a dramatic statement with a grouping of container pots—planted or not. Rather than setting pots here and there on your terrace or deck, try congregating several of the same type (but not necessarily the same size) in one corner. Massed together, and perhaps lit at night, the effect can be quite pleasing. Usually the larger the pots, the better. This will also aid you, in that the plants will not dry out so quickly, and will need less attention. Of course, one large pot, planted with a variety of flowers can be lovely. Choose from containers of terra-cotta, stoneware, stone, wood, plastic, fiberglass, or metal, realizing that each will react somewhat differently to environmental conditions.

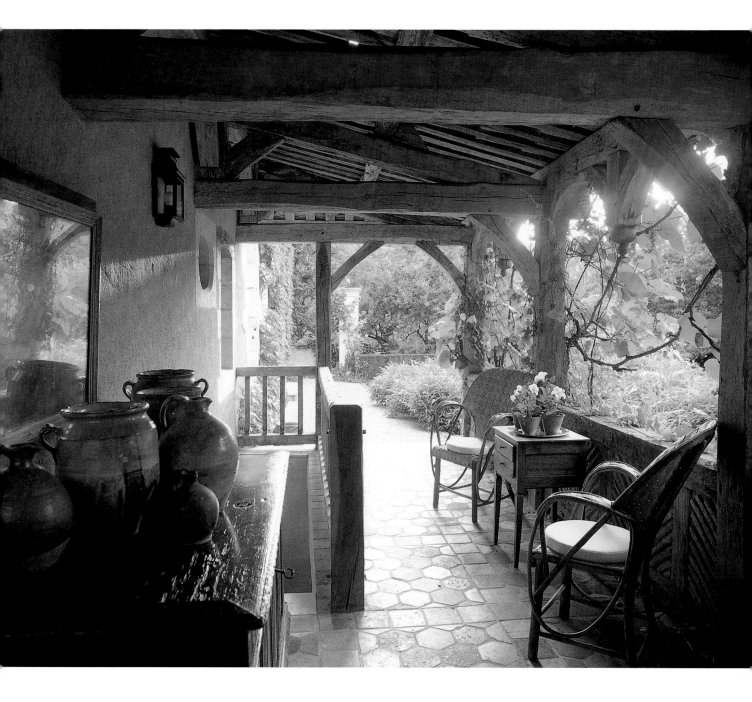

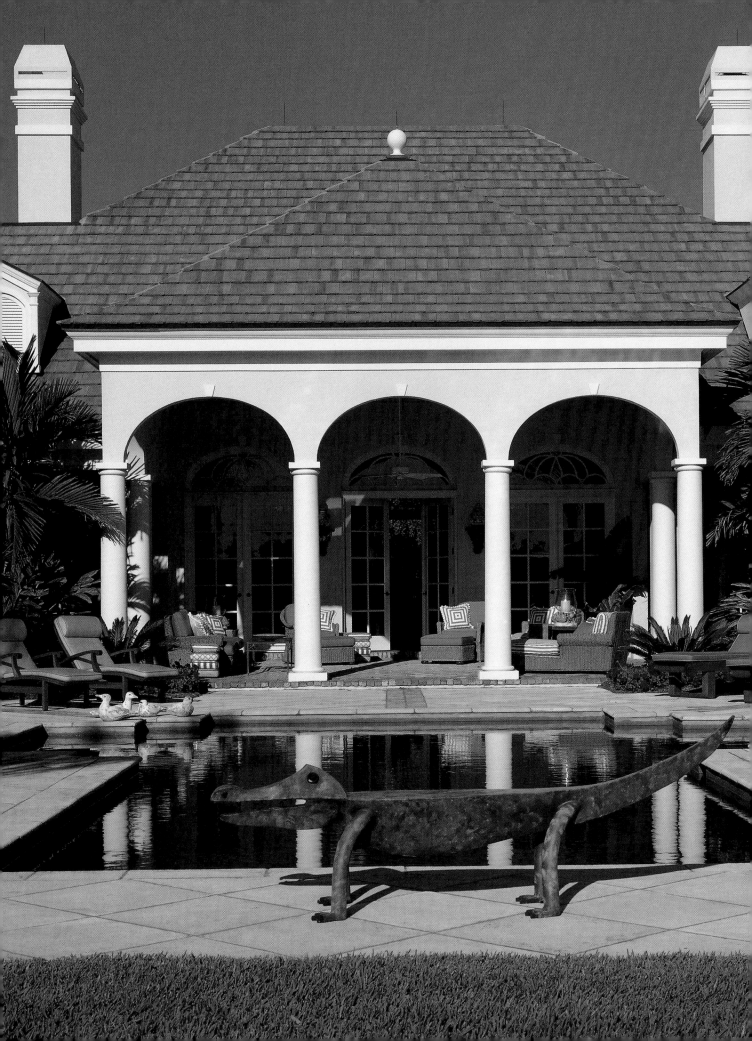

PUTTING IT ALL TOGETHER

If you've come this far in *Outdoor Decorating and Style Guide,* you may well be on your way to realizing your perfect outdoor room. But is there such a place? Probably not. Since the natural outdoor environment is anything but static, we probably wouldn't want perfection anyway. Hopefully, though, you may have gleaned some of the nuances necessary to put together the near-perfect outdoor room and with that new knowledge, more enthusiastically delve into the planning process. You'll discover many surprises along the way. In the end, you'll enjoy hours relaxing and entertaining in your beautifully designed outdoor room, an environment that will weather well with the passing seasons and the years.

step-by-step formula to outdoor decoration

1. Preliminary review of outdoor space(s)
2. Full examination of needs and potential uses of outdoor room(s)
3. Type of space(s) desired—i.e., type of outdoor room(s)
4. Remodeling or building anew
5. Budget
6. Style options
7. Establishing the room's bones/perimeters
8. Hardscape versus softscape
9. Furniture options
10. Hard materials
 a. Paving
 b. Ceiling
 c. Walls or fencing
11. Fabric and color
12. Decorative accents
13. Special features
14. Maintenance
15. Enjoyment, relaxation, entertainment

left
All the essential elements come together in a lavish loggia/pool pavilion. The blue cushions and the teak and wicker chaise lounges reflect the color of the sky and water. A sense of proportion and balance is achieved in the arrangement, and a bit of whimsy, with the alligator sculpture sitting at the near end of the pool.

CHAPTER FIVE

CLASSIC

The Greeks and Romans introduced a classical formality to architecture and design and in turn, to outdoor decoration. The principles centered on symmetry, balance, harmony, and a strict sense of proportion. Villas and palaces featuring interior gardens, terraces, and atria opened to the sky, surrounded by arcades supported by Doric, Ionic, or Corinthian stone columns, and watched over by statues of the gods.

Over the centuries, the classical has become synonymous with formal design and restrained elegance. Think of the grand estates of the European Renaissance or of the nineteenth-century North America industrialists. These outdoor rooms were rigorously symmetrical in their landscape design and accented with classical flourishes. These were places for lavish, formal parties, as well as personal pleasure. Now, in the twenty-first century, we celebrate what remains of their beauty in garden museums and private country estates.

It's easy, however, to re-create the elegance of a formal outdoor room—be it a true classical style, neoclassical look, or one just brings the aesthetic principles to a different design venue. There's a rigidity to its symmetry, balance, and proportion that produces a highly ordered environment—and a certain formality—that can be adapted to any outdoor look. Elegance shines through a restrained palette.

Think also of classical outdoor progressions—or a continuous series of areas for entertaining. And, if you are fortunate enough, the site will allow for areas to shift to different levels. From the formal entry hall of the house, one is drawn outside through classic French doors that open onto wide stone steps. Flanked by terra-cotta pots, the flagstone steps lead to the inviting reaches of the terrace. Beyond that is the formal garden. From the terrace, walled brick steps lead to a sweeping lawn outlined with perennial beds. At the other end of the terrace—the living room portion near the blazing hearth—steps lead down to the pool area and its pool house that doubles as a guest house. There you'll find chaise lounges and table and chairs for informal entertaining.

the earliest garden rooms

The desire to arrange our outdoor spaces into organized "rooms" reaches back to antiquity. The earliest surviving detailed garden plan is thought to be that of the estate of an Egyptian high court official of Thebes from c. 1400 B.C. There, a straight path covered with a pergola leads to the main entrance of the residence. Parallel with the main axis, tree-lined avenues lead to self-contained, wall-enclosed "rooms" containing ponds and pavilions. Historians believe that similar enclosed pleasure gardens may have been designed as early as 2800 B.C.

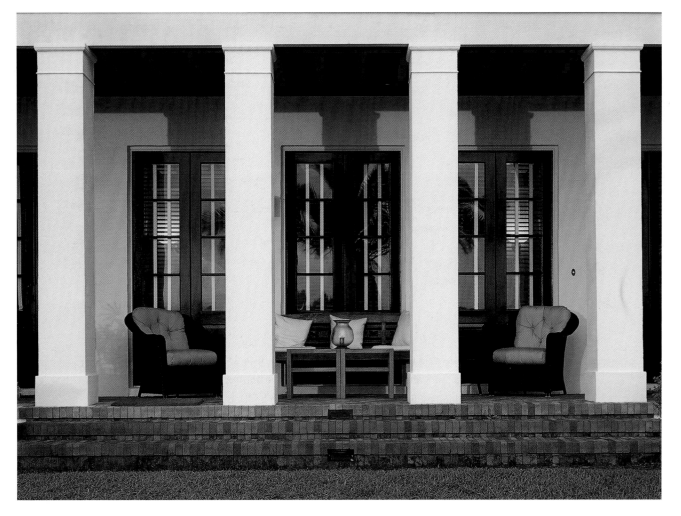

above
Strict classical design principals, such as a rigorous symmetry, repetition, and unity, can make a contemporary design seem classic in its own right. This loggia does not include classical elements per se, yet its bold presentation and symmetry promote a restrained formality.

CLASSIC PROPORTION/ SYMMETRY

The walls of outdoor rooms are astound- ingly variable and can be shaped by group- ings of furniture, as well as the existing walls of the house, railings, fences, or plants in the garden. Within that "room" a symmetrical placement of furniture immediately signals a formality through its well ordered uniformity. That ambience is heightened when the outdoor room has multiple formal activity areas designed with the same graceful restraint. Carefully placed ornamental details expressing a classical motif—statues, urns, or gar- goyles—further establish the mood. Purity of vision is encouraged. Only a few objects are needed to reinforce the theme of the outdoor room.

Pure classical design is based on disci- plined lines, mathematical laws of propor- tion, and ornamentation of ancient Greek and Roman art and architecture, revived during the Italian Renaissance. For outdoor decorating, concentrate on the principles of cool elegance and restraint, symmetry and balance, geometrical forms, clean lines and classical details, such as columns and pilasters. Develop your own interpretation of the classical—what suits your lifestyle and needs. Use a little imagination to see where the lines of formality can be drawn.

The classic doesn't need, however, to draw upon classical elements. Any aesthetic can be presented in a classic manner, using strong principles of proportion and sym- metry. For example, in one setting, a teak table and chairs can look quite informal on a rustic deck, but positioned in an other- wise formal setting, can take on a grander image. And when decorated with formal- ware, that image is further reinforced.

classical accents

Decorative details visually work to establish the mood of an outdoor room. Consistency is crucial if you are seeking a specific style. Many classically designed elements can enhance the formality of your outdoor room—urns, pots, fountains, statues, birdbaths, and more. Materials range from metal to terra-cotta to stone. When choosing what to include, practice the design principles of a balance, scale, and repetition. Remember less is more. Sometimes, focusing on one or two objects can have more impact than cluttering the space with many different pieces.

Although perhaps not as popular today as in other eras, wrought iron furniture evokes classicism. And why not? Iron was produced as early as 1000 B.C. And the Victorians loved it. In that era, the simple perforations in the tables and chairs that were designed to allow water runoff turned highly decorative. Today, all styles are available—patterns can be very ornate or minimal. Several types of metals are used: true cast iron, aluminum, steel, or composites. Advanced finishing products provide more durable surfaces. Wrought or cast iron tree benches can be also be used to circle porch columns.

Massive stone and marble also bespeak the classical. Fortunately, modern methods provide faux materials that are much lighter and less expensive. Chairs can be fabricated to resemble ancient massive stone seats or benches. Elaborate stone urns are cast to be lightweight. Even classical statues are light enough to transport easily. And don't forget the classically inspired fountain that brings the sight and sound of water to your outdoor room.

left
Add a bit of whimsey with a statue of a woman's head, crowned with white lobelia, from Charleston Gardens.

FORMAL ENTRANCES

Set the stage for your guests with a carefully planned formal entrance. This is, after all, the most frequently seen space at your home and you may wish to convey a warm sense of welcome. And the entrance is often where the entire house is first judged. That pathway can be inviting and formal at the same time. Let the architecture of your house determine the scale and grandeur of the entryway—whatever form that entryway takes. A white picket fence and arbor gateway, for example, can gently announce a clapboard house beyond. The edge of the property can be defined by a low stone wall. Other properties may have a larger stone wall and metal gate as a formal entrance. A small cottage may require a simple wrought iron or wooden gate and an English cottage-style garden.

Beyond the arbor gateway is the outdoor foyer. Here is the first outdoor room, which may simply consist of a pathway and a small garden leading to the front door, or could be an elaborate garden or expansive lawn. Provide a path wide enough for two people to walk side by side while enjoying glimpses of the varying sizes, shapes, leaf textures, and colors of foliage and views of the house. A decorative bench placed at a strategic point can serve as a welcoming seat, a place to linger, or a waiting area. Create a sense of anticipation and surprise.

gates and doorways

We think of gates and doorways in terms of protection—keeping unwanted persons and animals off our property. When decorating outdoors, both gates and doorways, however, can become special design elements in a plan. Why not make them artistic statements? Hire an artist to design a decorative wrought or cast iron gate for your front entrance. Or purchase a used one of artistic worth. Try painting a wooden door an unusual color to highlight it. Historically, gateways were considered highly important and were designed to impress; they usually carried a coat of arms or motto of the occupant.

Currently significant architectural features of contemporary gardens, gates aren't necessarily conventionally designed. It's best, however, to have a minimum opening of at least 3 feet, while the opening of double gates should be at least 8 feet wide. Materials could include metal, wrought or cast iron, painted aluminum, galvanized steel, or timber.

left
Gateways offer a glimpse into an outdoor room and, therefore, build the sense of anticipation. Here, a coral-painted doorway with decorative metal bars announces the room's entrance and, at the same time, adds a gentle spark of color to the garden.

outdoor easy —
building an arbor trellis

In the classic movies, arbors are often the romantic rendezvous spots, where the leading lady and her man meet after dark for their first kiss—or maybe their last. In real life, arbors can range in size from small entrance ways covered with roses to large trellises protecting an entire table from patio or terrace in the heat of a summer day. A basic arbor is simple to construct.

Pressure-treated pine or naturally decay-resistant cedar are the most common materials used to construct an arbor. The goal is for the arbor to support the weight of the plants that will grow or be set upon it.

the design:

Decide upon the size and spacing of the rafters, as this determines the size of the support members. Rafters can be plain or fancy—ending in curves, notches, or elaborate scrollwork. The rafters can be left uncovered or covered with cloth, plants, lath, or lattice. In the design, you'll gain a sense of unity by repeating an architectural detail of the house, such as the pitch of a gable, window trim, railing pattern, or paint color. Arbors vary in height, but usually range from 8 feet to 10 feet. If covering the arbor with plants, leave plenty of headroom for the vines growing overhead to droop down. Also, when deciding upon the arbor's length and width, remember that a roof overhead always makes the floor space below seem smaller.

the construction:

Concrete footings will support the weight of the posts, arbor, and plants. Piers of cast concrete are embedded in poured concrete footings. Posts are 4-by-4 lumber or larger. Post-to-beam connections may need bracing. Metal anchors secure posts to piers or to a concrete slab. Rafters sit atop beams and are spaced for plant support or shade. Orientation determines the extent of shade cast below.

right
A wooden swing hanging in a small arbor creates an intimate retreat. Its architecture echos that of the main house. Vines cover the support columns.

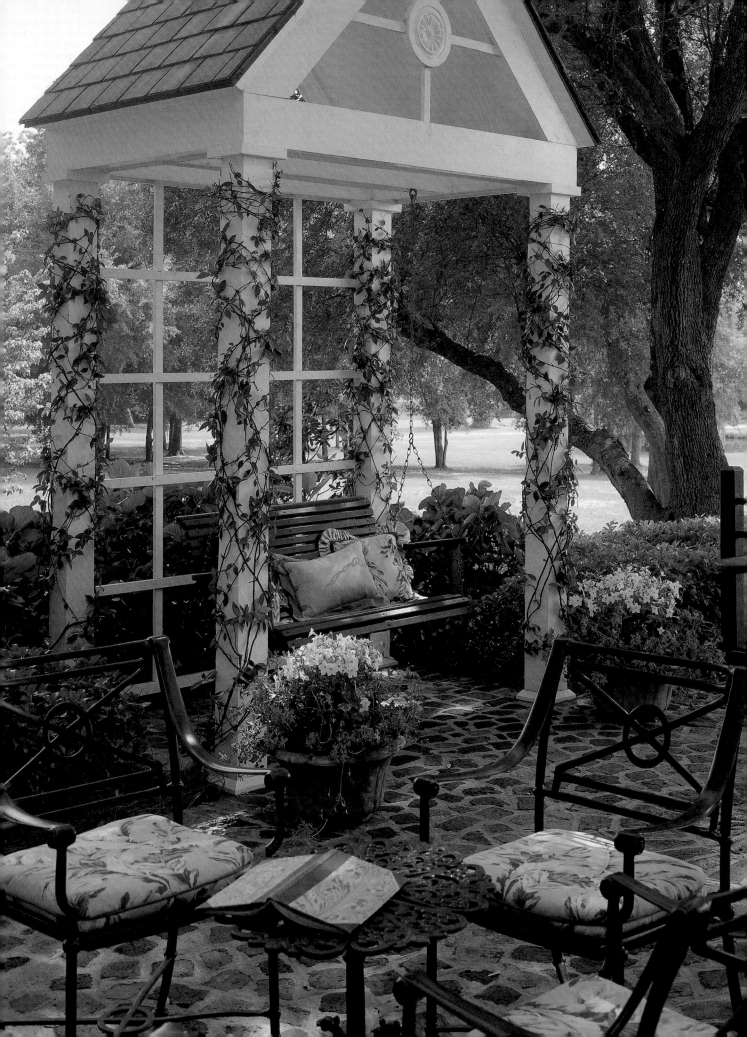

CLASSIC MODERN

above and right
Considered classic—and neo retro in design—are accessories such as the mirrored gazing ball and ceramic pots with decorative motifs that reflect earlier eras.

Modern design shuns excess ornamentation. Modernism is considered a "classic" style, hav-ing had its heyday in the early 1990s. A pure modern look is very retro now, and very trendy.

The Modernists streamlined design, removing the frills and excessive decoration of earlier eras such as the high Baroque. The new look sought uncluttered spaces and clean lines. A truly modern outdoor room has an almost sculptural quality. The shapes of the furniture and other decorative elements are simple geometric forms. Colors are crisp and bold. Vegetation is architectural and massive, with large-leafed plants and spiky grasses. Accessories are restrained. In these modern designs, industrial or hard-edged materials are present, such as pipes used as hand railings or industrial light fixtures. We've all heard the clichés, yet they ring true: "Less is more" and "Form follows function." The modern era brought all the synthetic materials, such as plastics and polyesters that we now take for granted, several of which make outdoor living much easier.

The classic modern is a minimalist design that often needs minimal maintenance, but if designed with care can be strikingly beautiful, particularly in the natural environment.

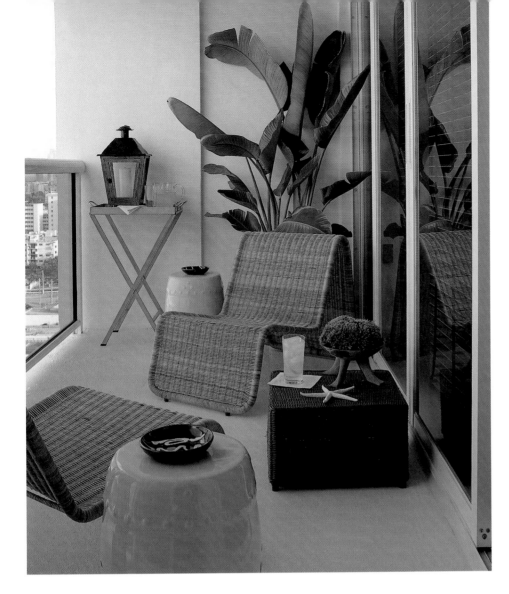

The minimal-style wicker chairs bring a modern tone to this small balcony. Accompanying the chairs are the carefully chosen, geometrically bold, shaped ceramic side tables, wicker end table, and an over scaled lantern, each carefully placed on the balcony. A tropical plant adds a touch of the exotic.

plastic pretenders

Plastics in the outdoors no longer connote cheap and cheesy, such as plastic flamingos and five-dollar drugstore chairs. For your outdoor room, plastics can range from lounge chairs, to Adirondacks, flower pots to urns and pineapple-shaped finials, fishponds to trellises. In fact, the deck itself can be made of plastic, and the fence, and even the stretch of emerald polyethylene grass. And, of course, all the accessories are plastic—from the citrus lights to the flower-shaped plates to the matching tumblers and cutlery. It seems everyone is getting into the plastic mode—from Amish craftsmen, who build and sell gazebos, swings, and other furnishings made of vinyl-clad wood or "plastic lumber" to others that produce Victorianesque bistro furniture or postmodern sofas, or Arts and Crafts lanterns.

Plastic, after all, lasts virtually forever. It requires little upkeep, never needing painting or sealing. It is less likely to shatter if dropped than other materials, or crack if left out during the winter months. And, it's a less expensive material to work with. Products can be made from recycled materials, such as used milk jugs, soda bottles, coffee cups, and grocery bags, so many consider plastic eco friendly. Of course, true environmentalists would argue just the opposite—that once discarded, plastic has a long nonbiodegradable lifespan. A piece of plastic will sit in a dump for many years to come. No doubt, though, plastics are here to stay. Consumers are demanding and getting much higher quality projects, with greater design aesthetics. Look for plastics or composites that mix plastic with sawdust, paper, glass or other recycled materials.

ROMANTIC

In our dreams, there is that most romantic place we travel to—a small, luxurious cabana located on a remote, pristine, tropical beach or a rustic mountain hideaway—where we briefly escape and relax and shut out the rest of the world. In reality, we might like to bring just a bit of that magic into our daily lives. What better way than to connect with nature right in our backyards or urban rooftops, and to do so with a touch of fantasy and imagination, if not romance?

The accoutrements of romance spring from each person's mind, yet seem to include things related to luxury, abundance, softness, a connection with nature, and a chance for quiet contemplation and relaxation. Romantic touches might simply be candlelit dinners on the terrace, a quick soak in a hot tub on a cool evening, or a bouquet of beautiful flowers decorating the porch table.

Think of those lazy summer afternoons, when one's agenda simply calls for a cool drink, a comfortable chair, and a good book or a couple of friends to chat with. Perhaps you would like to set up a simple awning or tent in the woods on your property where you could constantly return to watch the changing seasons? Or have breakfast underneath a trellis overgrown with honeysuckle?

Consider your own outdoor room. What physical amenities would heighten your comfort? How can you design more romance into your environment? Later, in the evening, candles or lanterns can light the way.

right
It is dusk and the evening sky is just getting dark. On the terrace, the light begins to glow from the several wall lanterns and from the candles set on the table. Dinner is about to be served for you and your three guests. A soft wind is blowing from the east across the ocean. You can smell the food the chef is preparing and sense the anticipation of your guests. A romantic enough setting?

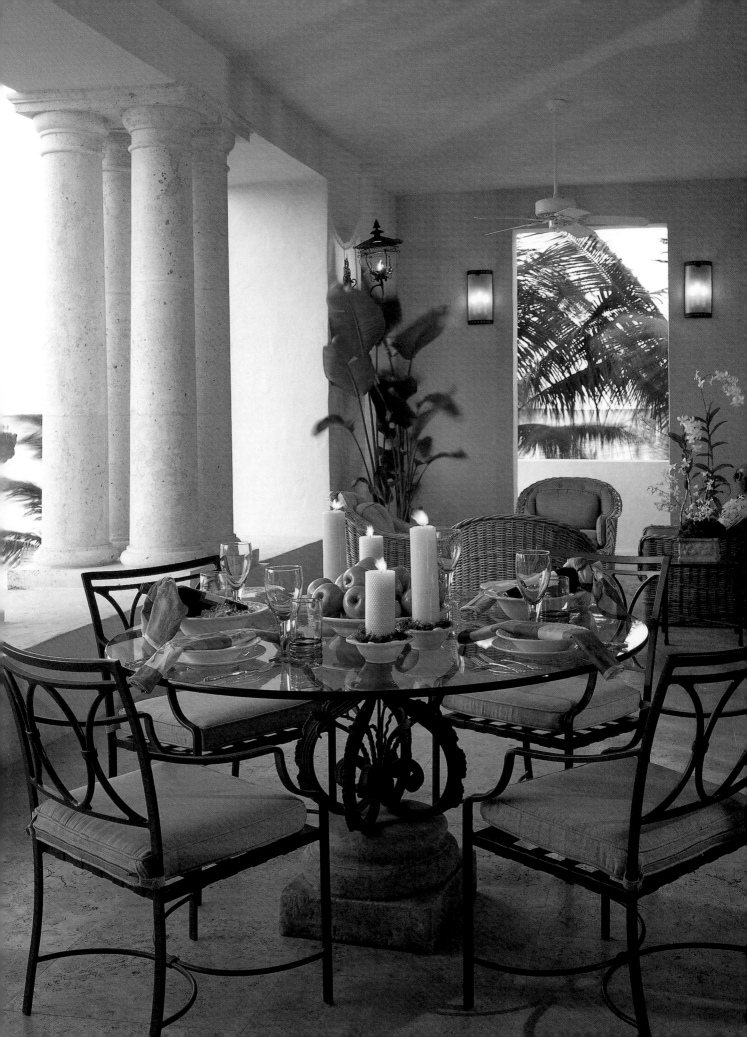

THE TRADITIONAL ROMANTIC

Wicker is a sentimental favorite in garden furniture and lends a highly romantic profile. Currently, the term wicker is used as a catchall word to include rattan, bamboo, reed, and machine-made, paper-fiber furniture. Perhaps, the most romantic, though, is wicker, the old-fashioned furniture made of straw reeds or willow shoots. Wickerwork reaches back to the Egyptians in the third millennium B.C. and has always flourished where there was a plentiful supply of riverside vegetation. Of course, beginning in the nineteenth century, more complex and specialized forms evolved, and wicker, in fact, became a popular seat on ocean liners. The furniture looks substantial, yet is lightweight and easy to move. Its construction actually allows it to breathe in humid climates, and it can be naturally weathered or painted. Wicker is now weatherproofed for continued outdoor use.

We romance the past—and traditional wicker furniture harkens back to Victorian times. Add cushions with large floral prints, like Grandma used to have. And, of course, add vases of fresh flowers and a pitcher of lemonade and some extra glasses. Nostalgic is the word. It's easy to be transported back in time. Cozy up in a wicker rocker to a roaring hearth. Or on your expansive Victorian porch, a 10-foot wicker sofa strewn with pillows spreads nicely over an oriental rug. The antique lamps add to the homey feeling.

Modern forms of wicker are also enticing. Line up several minimalist chaise lounges alongside an abstract-shaped pool in Fuji and ask about romance!

right
Capture the traditional romantic ambience with Victorian-style white wicker. Seen here in several different styles of armchairs, a rocker, tables, and a footstool, the wicker portrays an image of an earlier era, heightened by large floral prints and large floral bouquets.

a rose is a rose is a . . .

The rose is a symbol of love, invoking sentiments of the heart. What could be more romantic in your outdoor room?

Roses are available in an enormous range of flower colors, shapes, and scents. There are, in fact, about 250 naturally occurring species of roses, as well as many natural hybrids, growing in the wild. Choose from the simple purity of the wild rose, the soft, pastel charm of the old garden rose, or the jewel-like brilliance of modern hybrids. Surround yourself with tiny pot roses or a foaming mass of huge ramblers. The advice of horticulturists: "Growing roses is not difficult." Meet their basic needs: sun, water, and occasional fertilizer, and you'll get a profusion of color and fragrance.

Favorite cut-flower roses are hybrid teas or floribunda. Typically grown in rose reds, hybrid teas offer bright colors, elegant forms, and long stems. The floribunda varieties are more free-flowing, and compared to the hybrid teas, are generally a tougher species. Both, however, are particularly vulnerable to fungus and insect pests, and require regular programs of spraying, feeding, and pruning to remain healthy. Their hardiness also varies; most need winter protection in colder climates.

Shrub roses, however, seem a perfect solution for the outdoor room, particularly for the less-skilled gardener. Fuller plants, shrub roses lend themselves to use as screens and hedges, as well as specimen plantings and, therefore, can serve as walls for your outdoor room. Today's shrub roses are a result of crossing of old rose types with modern roses, and offer the best traits of both: repeat flowering, a wide range of colors and fragrances, good growing habits, and hardiness. Shrub rose favorites include Starry Night, Knock Out, The Fairy, Sophy's Rose, Miss Alice, and Carefree Sunshine.

Don't forget climbers for your trellis or miniatures for your container pots.

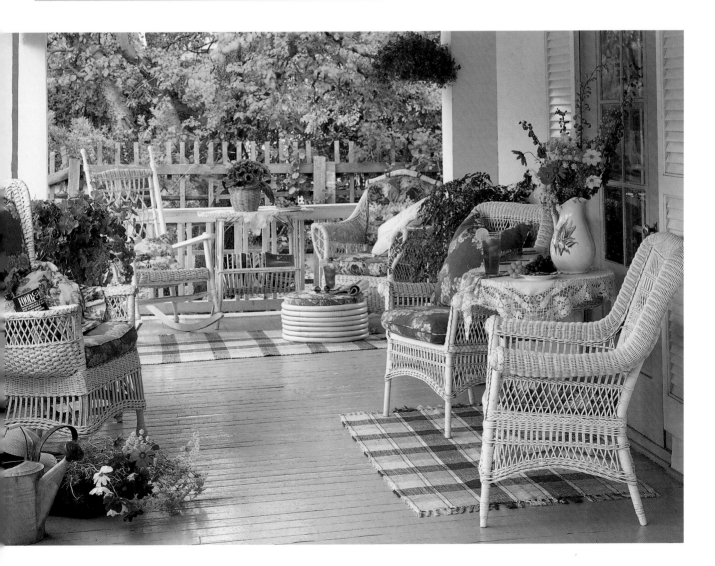

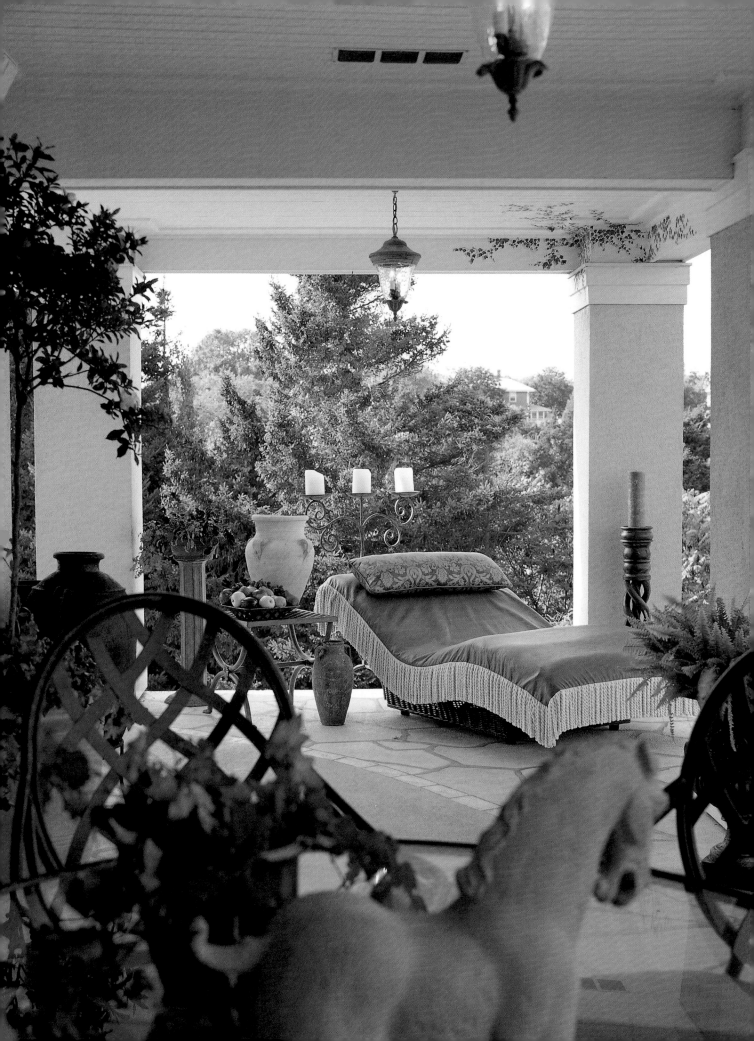

SOFT, SUBTLE ROMANCE

To set the stage for a romantic evening, go soft and elegant. Pretty up plain chairs and benches with lacy cushions and floral fabrics. Add a mountain of satin pillows. Or pull out the velvets and silks for a truly extravagant touch. Choose soft, delicate pastels or announce an evening of passion with bright reds and deep purples. Create a sense of luxurious ambience with ornate terra-cotta pots or cast iron urns filled with plants or flowers to match the hot colors. Make sure the flowers emit an enticing fragrance—or light some incense. And, don't forget the gentle glow of candles at night—lanterns around the terrace and candles on the tables. Twinkle lights add a nice sparkle. Turn all the lights off, but shoot a spotlight up a tree.

While you wouldn't want to keep your elegant fabrics outside permanently, in your sunroom or protected porch, the options are much greater. There, you can add a silk throw, or cover a sofa in a velvet material. Hang chandeliers from the porch ceiling. So, perhaps, it is easier to establish a permanent romantic enclave there. Always have a vase of freshly cut flowers. Again, the key is to think in terms of all your senses.

three-dimensional design

Romance comes in three dimensions. When thinking of the romantic outdoor room (or the sunroom or enclosed porch), consider these sensual contributions:

1. Smell: Plant something fragrant, such as jasmine, Daphne, rose, or rosemary. Light a scented candle or some incense.

2. Texture: Mix the delicate with the bold in foliage, flowers, and paving. Combine different types of fabric that contrast visually in texture or color.

3. Touch: Try fuzzy foliage, such as lamb's ears, or the prickly sting of cactus. Contrast gravel with the smooth surface of polished wood.

4. Sound: What about the chirping of birds, the splash of flowing water, or the chimes of a wind catcher?

5. Taste: Wasn't that appetizer delicious? And the wine? (Yes, even taste. Serve something special. Your room might be remembered for the sensation.)

In other words, engage all your senses in the planning of your outdoor room to achieve its full romantic potential. Wasn't that a monarch butterfly that I just saw?

Capture intriguing fragrance by planting the following: lavender, honeysuckle, lilies, evening primrose, mock orange, common jasmine, sweet peas, tobacco plants, and star jasmine, fragrant late-flowering roses, cotton lavender, myrtle, rosemary, sweet bay, and thyme.

left
Be nostalgic and adopt the romance of an earlier era. With its chaise lounge flanked by urns, candles, paved flooring, and statuesque horse, this setting suggests classical Roman, yet the electric lights reveal its modernity. The eight-inch trim and fabric pillow add softness to the luxurious faux-leather chaise cover.

outdoor easy — lighting at night

below
Candles fit snugly into flower-shaped torches and add a dash of light along a pathway.

far right, top
Hang lanterns for sparkles of festive lighting at nighttime.

far right, bottom
Torches add an exotic touch at night.

Nighttime brings out the most romantic in all of us. In outdoor rooms, most anything goes. The moon and stars are nature's built-in illumination. Their faraway brilliance seldom meets our outdoor room needs, and both artificial and candlelight add to the romantic ambience. Typically, candlelight and low-voltage artificial light can soften the most hard-edged spaces and go a long way to meet your lighting needs. But don't be afraid to try different lighting schemes. Obviously, different functions will call for different light intensities, and it's easy to switch lighting levels. In fact, lighting is one of the most versatile design elements.

A great variety of garden lighting is available, including solar-powered lights. Consider spotlighting particular sections of the landscaping for special effect, such as a specific tree or a potted plant. Or try hanging elaborate chandeliers over terraces or on porches. Bring out your antique lamps with wicker or silk shades and blur the boundaries between inside and out. All kinds of lanterns can add festivity or an exotic mood to the scene— Japanese, Scandinavian modern, Greek fisherman, or Moroccan. Or place Deco torchières strategically around the garden and let the glow of their lights soften the darkness. Hurricane lamps do well in windy conditions.

Decorative lighting can also be used to emphasize form, pattern, texture, and shadow; provide general lighting; way finding; and festive sparkles. Like everything else in your outdoor room, it's helpful to plan early for what your lighting needs will be, particularly when your plans involve access to electricity. Most often outdoor lighting will be low-voltage, which involves the use of transformers that reduce the household current to 12 volts. This consumes less energy and is easier to install than standard fixtures, and is safer and more portable. The number of lamps that can be attached is limited. Make sure you choose high-quality metal or plastics. Transformers, cables, and lamps can be hidden in foliage. Use spotlight to uplight or sidelight trees or potted plants, for effect. Another option does exist, however, go entirely solar-powered and supplement that light with candles and torches.

Outdoor lighting has a practical, as well as mood-setting purpose. Visitors need to be safely guided along a path, and perimeter lighting can discourage intruders. It's also easier to barbeque in adequate light. Decorative lighting can be fixed to the house on a porch or deck. Use candles in lanterns or twinkling minilights strung in the trees. Use the lights of the swimming poor for atmosphere. Lighting schemes are easy to change. Next week, try a different lighting combination. It's quite easy to switch torches for candles for twinkle lights. Let your imagination run free.

THE PLAYFUL
AND FANTASTIC

Amusement and delight. We have permission to be as playful and as fanciful as we would
like in our outdoor rooms. There is simply no reason to hold that fantasy inside any longer.
Sure, the play may be an extravagant fantasy that might fall more into the exotic category...
or it might resemble some of the fun presented here. Take out your paintbrush and find
an old set of chairs and have some fun. Plan a festival with friends and neighbors or sim-
ply enjoy the bright colors one season and tone them down the next. Take some color
clues from Winky's porch (see pages 58–59) or try *trompe l'oeil* (see page 89).

For other whimsy, add topiary animals to edges of your outdoor room or incorporate a table
of found objects. Paint wooden birds or grow vines in moonshine crocks. Go to an antique
store and discover a 1920s glider or an iron daybed and place them on the porch for reading,
snoozing, or entertaining. Let the child—or least the child's imagination—emerge.

above
Even welcome feathered friends with a bit of spirit to
brightly painted, striped birdhouses.

right
Brighten up your outdoor room with colorful stripes.
Adirondack chairs are painted white with pink, blue, or
green stripes, and arranged around a matching green
and white striped table to create a playful scene.

outdoor painting techniques

For the lighthearted, simple wood furniture offers a decided advantage. It can be painted and repainted in whimsical colors to bring a festive air to your outdoor room. Some painting tips: Paint in fair weather, out of the direct sun and morning dew. Prepare the surface by removing dirt, grease, rust, and paint flakes. For new wood, paint the surface with one or two coats of latex or exterior wood primer. Then paint with flat latex acrylic, vinyl exterior enamel, or house paint. For cast iron furniture, remove every speck of rust, then coat with a rust-resistant paint.

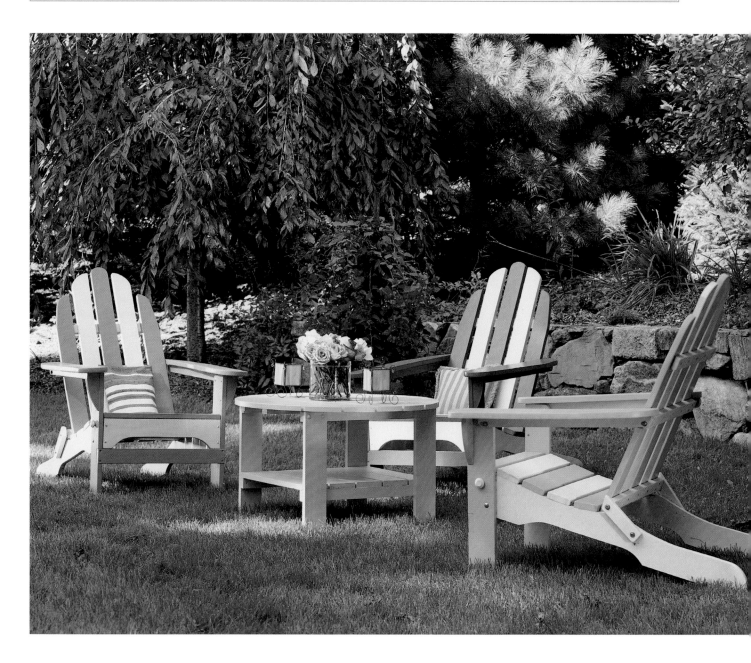

LOUNGING

In our busy lives, the big romance may be "relaxation." Perhaps, in the end, the most important element of our outdoor room should be the comfort level. What amenities have we provided to make this space just a hideaway for rest and relaxation? Can we design a pleasant, low-maintenance, but highly comfortable, corner tucked away from all our responsibilities? Can we find a place to lounge outdoors uninterrupted?

The most flexible solution is a hammock swung between two trees or two vertical supports. This lounger can be put up on demand, or can drift in the wind when unused. Keep some mats and cushions near by, which can be pulled out onto a patio, terrace, deck, or lawn at any time, for more comfort. Of course, you may wish

to concentrate on your relaxation with several chaise lounges and the main pieces of furniture. Don't forget the wooden swing on the porch. Or try a daybed tucked underneath an overhead, protective structure—or in a pergola or screened-in porch or summerhouse. Install a small pool or pond to aid in meditative reflection. The objective is to find that comfort zone and add a few essential amenities—and your hideaway is complete.

Or strive for a "designer" look. The outdoor furniture market is so specialized today that you can find up-end teak furniture, for example, that has remarkable beauty. Interior designer Philippe Starke has designed a series of chairs for outdoor living. Or look to classic antiques, like Chinese Chippendale, for your pleasure.

far right
Snuggle into the cozy corner of this outdoor room. Enjoy lunch and then siesta. A highly flexible space, its uses are many and its decoration simple but charming.

below
Serious lounging takes place on a balcony high above the water's edge. All that is needed is a cotton throw covering the wicker chaise, in case it gets chilly, a glass of sherry and some bright pink azaleas to bring some color to the outdoor room.

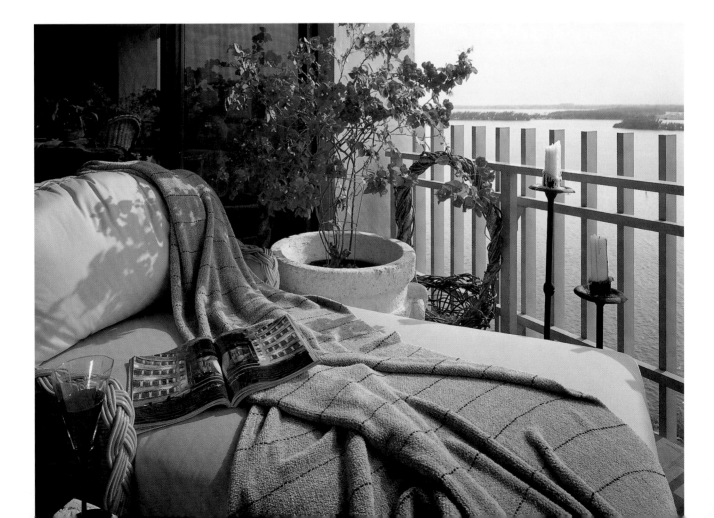

flexible spaces

Flexibility is a grand concept to consider when decorating outdoors. After all, the outdoor environment is meant to encourage your carefree personality. Let your outdoor room reflect that easy going nature and the chance for the unexpected. For instance, keep some folding chairs tucked away, so that when additional guests arrive the seating capacity can easily be expanded. Pot stands and even side tables can double as seats, if necessary. Or consider ways to extend you outdoor room on occasion, if desired.

When first planning your outdoor space, add some extra room, knowing that there will be times when you expand your normal activities. The extra space can otherwise be occupied by potted plants, if it seems too vacant. It's also difficult to anticipate exactly how the space will serve you far into the future. You will welcome that flexibility in the long run.

EXOTIC

above
Find an exotic spot and create your special room. Use your imagination. It can be a pier on a pond, where you'll have high tea. Decorate with café chair and table, add a flowery tablecloth, some delicious food, beverages, and flowers, and your room is complete.

If pursuing the exotic, here are two options: Call your travel agent and book a trip to a paradise island or decorate your outdoor room with unusual materials or objects, thus creating a mythical environment. Pick a theme—say, oriental, or choose a piece of abstract sculpture, an elaborate fountain, or a waterfall as your centerpiece. Consider seldom-used materials, such as a ceramic table and chairs or exotic fabrics and rich textures. Keep in mind the design principles mentioned earlier in this book—harmony, balance, scale, and proportion—to create a sense of unity.

To obtain the exotic, think of your outdoor room in three-dimensional terms. Let your imagination run free. Indulge your senses in mystery and intrigue by adding layers of texture, fragrance, sound, and vision. When you stop to think about it, what may be truly exotic is something uniquely designed for you.

If the natural environment itself is exotic, the outdoor room can be quite simple in its architecture and design—and its decoration. This is particularly effective in tropical and subtropical climates, where the landscape is naturally lush. No additional design flourishes seem necessary. Simply bold geometrical forms suffice. If your environment isn't quite so exotic, look to international sources, such as India, South America, Africa, and Mexico, for exotic cultural appeal in fabrics and accessories. If you can't travel to that far-away dream place, you can bring the mood to your outdoor room. With the exotic comes a sense of surprise and discovery.

the islamic paradise garden

The Islamic paradise garden, originating in the seventh century, is exotic. This type of garden was the ultimate luxury to desert dwellers. It was an oasis, a sanctuary that provided shade, water, and plant growth in the midst of the harsh desert environment. Here, the site and sound of water played an extremely important role. The paradise garden of the Koran featured an enclosed garden bisected by a canal. Pavilions lined the canal, surrounded by gardens planted with an abundance of flowers. These gardens, like those of the Alhambra in Granada, created a sense of being in a jeweled private world, insulated from normal pressures. Expanses of water mirroring the sky gave an impression of spaciousness and introduced lightness, brightness, and an air of unreality to the enclosed space.

right
Eclectic can be exotic. Try combining favorite decorative objects, furnishings, and serving ware underneath the arbor. Experiment. It may be a difficult design task to get the balance and scale correct, but it can be electrifying.

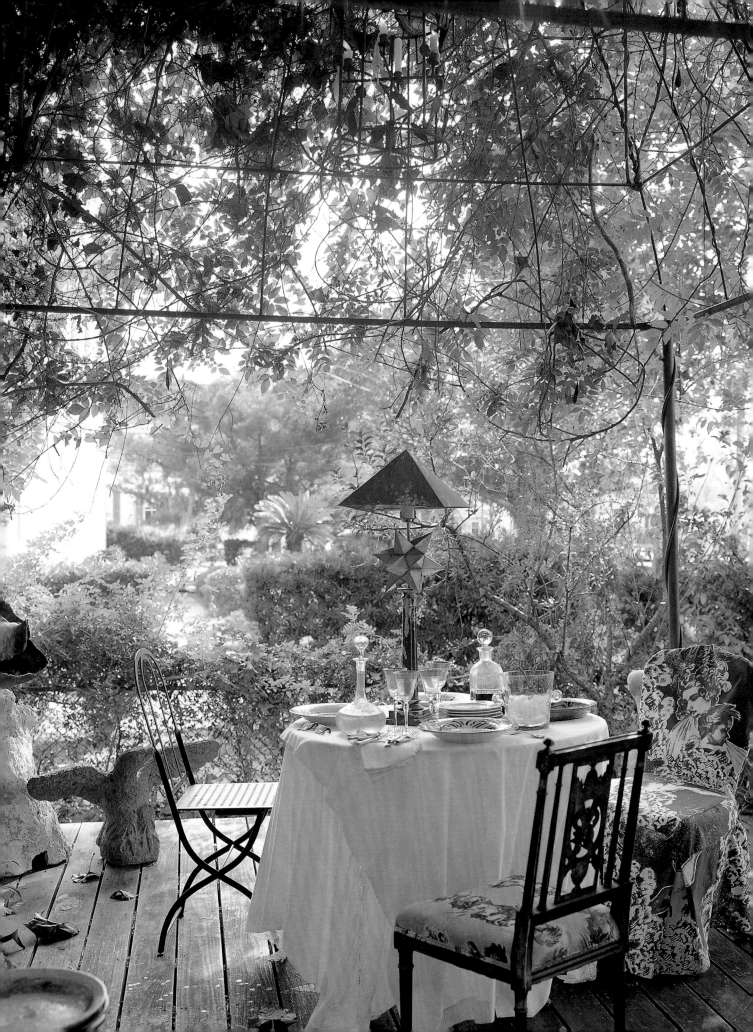

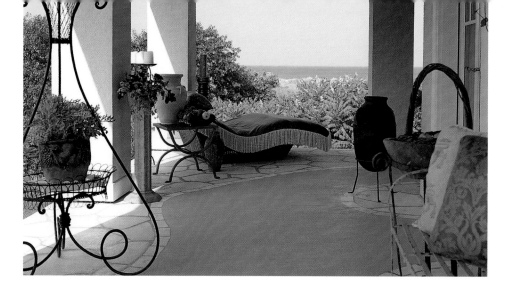

A double-width chaise lounge is the focal point of this fantasy outdoor room designed by Rick Botieri. Draped with a custom-made faux-leather throw trimmed with bullion fringe, the chaise is accompanied with over-scaled accessories with European flair.

ECLECTIC MIX

The eclectic can be most exotic. A combination of objects of several different styles and periods, the eclectic is highly idiosyncratic and individualistic. The visitor will pause a moment and just wonder if the scene was choreographed this way by the designer. Some elements may even be exaggerated in scale just for the effect. Often, it is a fantastical arrangement. Yet, somehow, a good designer brings unity to the whole fantasy composition. Sometimes the result is meant to be a bit tongue-in-cheek—a bit startling or surprising—and, in the world of high design, can portend the next trends in decoration. The fantasy may work best if its location is a startling space in its own right—either by its frame or that it offsets a grand vista. If you don't expect certain objects to be placed in a certain location, they can surprise and delight. Don't be fooled, though. The eclectic is an extremely difficult design style to perfect.

Interior designer Rick Botieri attempted the eclectic European in his design of a New England Museum show house. Rather than redesigning an interior room, he chose the porch, a "room with walls," of a 1904 stuccoed Craftsman-style house. With striking vistas across the marsh grass and dunes out to the ocean beyond, Botieri positioned the furniture to take advantage of that view. In fact, the double-width wicker chaise is set in the outer corner of the porch, so visitors can linger and gaze out to the ocean. To soften the wicker chaise, Botieri draped it with a custom-made faux leather throw with 8-inch bullion fringe. He added aluminum table and chairs that are lightweight and can be easily rearranged, and dressed them up with fabric that is echoed in the padded window cornice.

Adding to the tongue-in-cheek, European flavor are oversized terra-cotta urns and wine vessels. And, too, Botieri called upon the talents of decorative painters to use the special effects of *trompe l'oeil* and faux painting to add texture to the room. In *trompe l'oeil*, a lion's head appears on the stucco wall above the porch bench. In addition, the artists painted a flagstone path with cobblestone edging, a patterned carpeting, and ivy growing from the column to the ceiling. Overall, the atmosphere is one you would except to find in Renaissance France, perhaps, rather than early twentieth-century New England.

trompe l'oeil

A French word meaning "fool the eye," *trompe l'oeil* is an artist's technique in which an object is represented with such exactitude as to deceive the eye. The technique reportedly reaches back to the ancient Greeks, when it was said that *trompe l'oeil* paintings of grapes attracted birds to actually try to eat them. Currently, large presentations of these illusions of seemingly infinite space can be found on the sides of older, mid sized office and apartment buildings in urban centers—sides of buildings left blank because of some urban incursion. Richard Haas painted several *trompe l'oeil* walls in the United States, and David Hockney is also known for his *trompe l'oeil* art.

Trompe l'oeil can be used as a small or large decorative element in an outdoor room. The painting can be as small as the lion's head seen here, or fill an entire wall or side of a building. The artistic technique can transport a room to a location miles away, or can drastically change the mood.

Faux painting is another artistic technique that like *trompe l'oeil* adds to the decoration of an outdoor room. Faux art, which can be used to paint any object such as vines or floor tiles or stairs, is a flatter, two-dimensional image. Yet, from a distance, the images can nearly appear three-dimensional.

left
Is the scene above the wicker sofa real or imaginary? The *trompe l'oeil* is so realistic that one has to look twice to know for sure. On this terrace, it creates a lovely tropical mood.

outdoor easy — easy fountains

The sound and sight of water can be a refreshing addition to an outdoor room. British designer and author Sir Terence Conran goes so far as to suggest that "a garden without water is a place that lacks soul." He argues that water adds drama, depth, excitement, mystery, and the lure of the natural world.

Fountains, waterfalls, and pools can be quite exotic. Moving water heightens the sense of a lush paradise as it gurgles and rushes and drowns out urban noise. Fountains can be beautifully crafted and become the focal point of an outdoor room. Choose from among bell and dome fountains, rotating or geyser nozzles, wall or bubble fountains. To gain full advantage, be sure the fountain is spotlit creatively at night. Ponds add a visual splash, for those who love gazing at water and aren't near the sea or a lake. For color, fill a pond with goldfish or water lilies, umbrella grass, or horsetail rush. Perhaps even more sensational than cooling off on a hot afternoon in the swimming pool is the atmosphere created by the reflection at nighttime of underwater lighting. Even the light emanating from a hot tub changes a typical deck into an exotic outdoor room.

While ponds, fountains, and waterfalls can be quite elaborate, it's also possible to start small—to get your toes wet before jumping into the deep end.

Try creating a basic fountain from a wooden planter, metal basin, or large ceramic pot. Line the container with a flexible material or coat the inside with asphalt emulsion or epoxy paint. Place a submersible pump with a riser pipe within the container and run the cord through the drain hole. Conceal and protect the cord by running it through a plastic conduit to a grounded electrical outlet. Use a cork to plug the drain hole and hold the cord in place. Seal both sides of the hole with silicone sealant. Dry overnight and then add water. Plug in the cord. Presto. You have a working fountain.

For the design of a formal pond, British horticulturalist John Brookes recommends the following: Use waterproof concrete. Include in the design an overflow pipe to prevent flooding and an outlet to a separate drainage field to allow for occasional cleaning. Where frost is light, use reinforced concrete and build the pool with sloping sides so that as the water freezes and turns into ice, it has room to expand. In colder areas you may need to empty to pool entirely to prevent frost damage. Pool copings should rise above the water by at least 2 inches (5 cm) to hide any change in the water level due to evaporation, and to conceal the green algae strains that inevitably occur where a surface meets the water.

SWIMMING POOLS

A delightful escape from the heat in warm climates, swimming pools do dominate the landscape. The average size pool is thirty-three feet by sixteen feet (10 meters by 5 meters). Of course, pools come in different sizes and configurations; yet, unless it is a small pool just for cooling off, in all likelihood it will be the center of an outdoor space.

Swimming pools are a relatively new addition to outdoor rooms. English gardens have featured "cold baths" since Georgian times. Outdoor swimming pools became glamorized after the First World War, and with the extravagantly choreographed films of fabulous actress/swimmer Esther Williams. All of a sudden, sleek, modern-designed pools were all the rage.

Currently, pools are designed in a variety of shapes—rectangular, oval, square, kidney, free-form, and round. Often they are shaped to fit the particular landscape, or perhaps designed to be simply a lap pool for exercise. Aboveground pools can be surrounded by decking and planting and integrated nicely into the setting. Paving and coping materials work to connect an inground pool with house and garden. Choices of tiles for the pool itself range in colors. Turquoise blue works well in southern climates, but dark greens, blues, and grays tend to complement the surroundings better in cooler zones.

Hot tubs and Jacuzzis have become much more popular over the last decade. Much smaller in size and, therefore, more readily tucked in corners of a garden or outdoor setting, a hot tub or Jacuzzi can be used practically year-round—and turned on and off with little fuss—and make an attractive water addition to an outdoor room when entertaining. Screening the hot tub—both for privacy and for shelter—is important. Use very lush groups of bamboos or large palms in pots or design a pergola over the top of the tub for privacy from the neighbors.

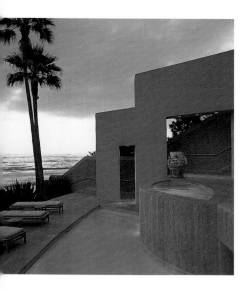

above
A hot tub sits a level above the swimming pool in this starkly minimalist design. Modern-style chaise lounges on the terrace await swimmers, while the sea beyond beckons.

right
The swimming pool dominates the outdoor room, but in highly temperate climates the refreshing water is always welcome. Here a fountain marks the center of the pool. The eyes are drawn to the pool's edge by the bright red sofa.

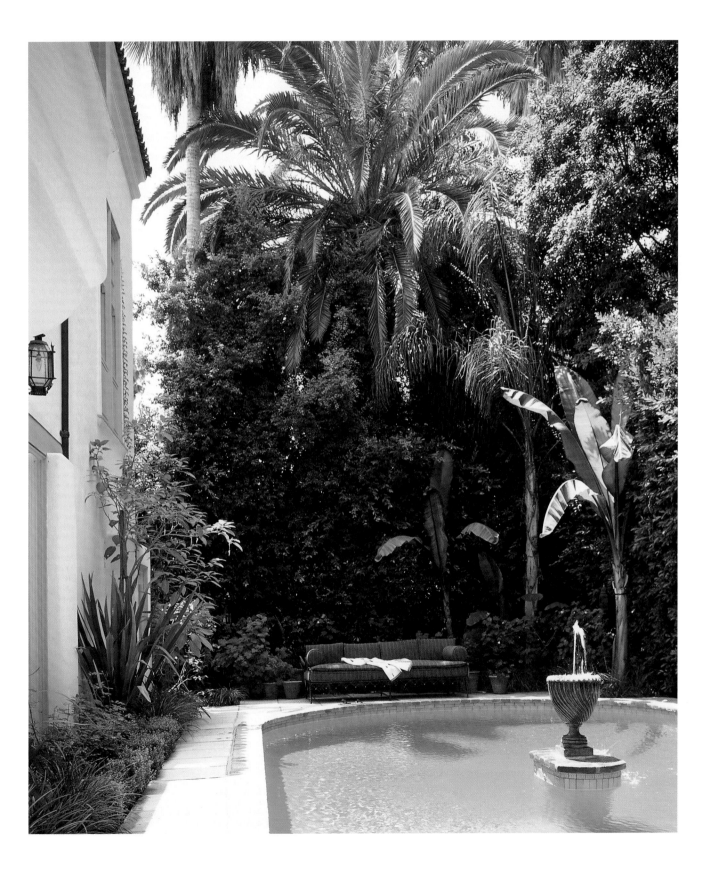

Dine Oriental-style in your outdoor room. A Japanese
table is inserted in a stone trough and surrounded by
soft pillows. Oriental accessories complete the scene.

ORIENTAL EXOTIC

The Japanese decorate with austere simplicity and a respect for nature. This Oriental spirit can be captured to create a calm and contemplative outdoor room. The basic ingredients are weathered driftwood, bamboo matting, and a wood-framed pergola. Add a motionless pond filled with bamboo spouts, approached by stepping stones and rocks and cobblestones. Swatches of cool greenery, rhododendrons, dwarf pines, azaleas, Japanese flowering cherry trees, and Japanese maple trees complete the scene.

Take for example, an incredible Zen garden planted on the fifth floor of a city townhouse. Approached through the master bedroom, the 20-foot by 40-foot Japanese tea garden design is based on the principles of dry rock garden design and meant to evoke a profound sense of peace and serenity, of nature revered and nature tamed. It incorporates classic elements of stone, water, and plants. From the bedroom, a platform extends out into the garden. To one side, a water basin provides clean water for the ritual purification necessary before beginning the tea ceremony. The basin is surrounded by stones on which to crouch. The middle ground of the space is planted with trees and shrubs. Walking stones lead to the edge of the garden and pass by four stone Buddhas. There are several different, intricate forms of bamboo fencing.

Oriental garden design originated in China, under the influence of Taoism (one should integrate oneself with the rhythms of life); Confucius (moderation as a means of attaining spiritual calm); and Buddhism (which elevated the attainment of calm to a mystical place). For the Chinese—and later the Japanese—garden design was, therefore, derived from the animistic beliefs of early civilization that all elements of the natural landscape, from the sky to bodies of land and water, were manifestations of other spirits inhabiting a shared world. The purpose of the oriental garden was to create harmony with the natural world using symbolic forms: male and female, upright and reclining, rough and smooth, mountains and plains, and rocks and water. In ancient Chinese gardens, seats and shelters were situated at chosen spots where landowners could savor such events as the moonlight shining on the garden or the dawn breaking.

Japanese garden design became a highly stylized, ritualistic version of the Chinese. Tea gardens, for example, have strict rules, the designs of which are meant to enhance different states of spiritual contemplation, such as the seclusion of the mountain shrine or the serenity of moonlight through clouds.

Other cultures, such as the Mediterranean or the Spanish or the Turkish, can likewise be captured by replicating local materials, customs, and foliage.

GREAT
ESCAPES

The word summerhouse inspires great fantasies; when summer comes, we pack our bags and move to a smaller, more airy home at the far reaches of the estate. Perhaps, though, playhouse has more meaning for most of us! Yet, while we many of us will never have a summerhouse to escape to, we might be able to incorporate a "great escape" on our property—a small, private sanctuary where we can, yes, escape from the rest of the world. No television or radio. CDs or taped music, maybe. The idea is to close the world off for a short time and just to be engulfed by the space around you. So, of course, that outdoor room should be decorated with taste and elegance—and perhaps most importantly, with your comfort in mind. Proper lighting is crucial, so you can continue most activities into the evening hours.

Conservatories now glass in more activities than just growing plants. Varying in size and shape, they now serve as lovely sheltered anterooms. Many have built-in shutters or blinds to control natural light levels, and glass panels that open to allow the fresh air to flow in. Conservatories can be also built to stand alone in the far reaches of the garden, and they can be temperature controlled to house plants year round.

For serious horticulturalists, a potting shed offers needed space for tools, extra pots, soil, and storage. Prefabricated sheds are offered at garden centers, but their designs are usually fairly pedestrian. Why not custom-design a small potting shed and paint it in a refreshing color scheme? The building type is relatively simple and the project could offer a would-be-designer several hours, if not weeks, of enjoyment. Turn the potting shed into a secret retreat. There might also be a child or two dreaming of a playhouse.

right
Escape to a poolside shaded terrace with a fabulous view of the ocean beyond. The bold, open pavilion invites diners in after a long day of sun and swimming.

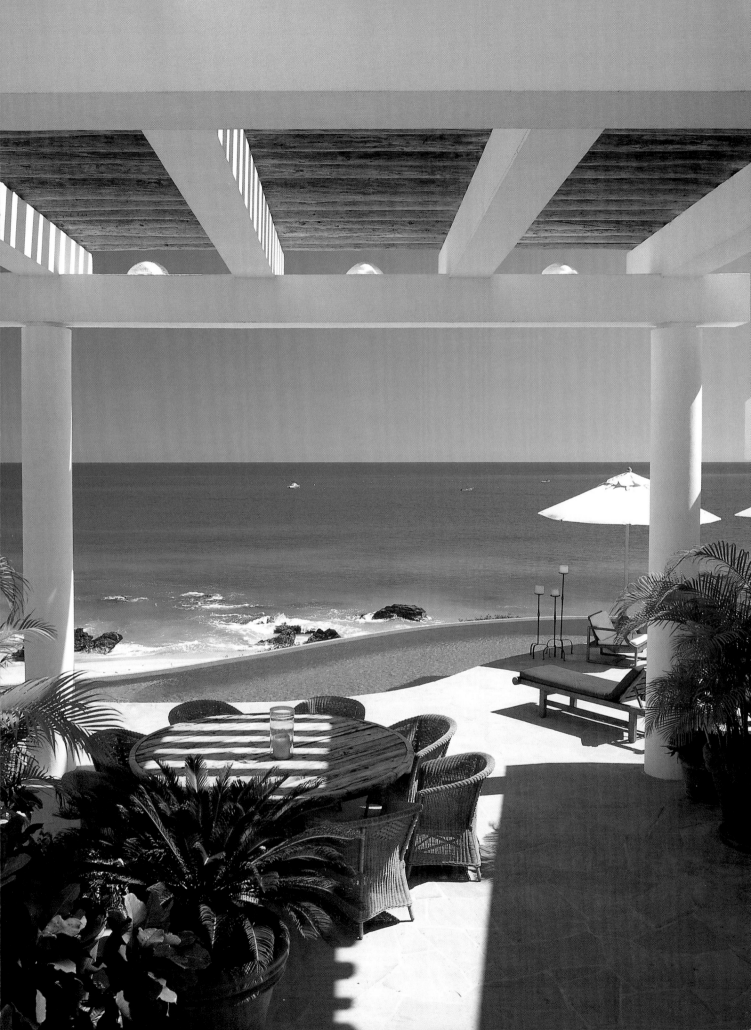

CONSERVATORIES

Centuries ago, aristocrats in Europe erected the first conservatories (then called orangeries) to house exotic fruits and plants. Modern-day conservatories are still considered winter gardens, yet their use as a building type has radically expanded. Now a conservatory might be called a natural light house or a nature house, its connection with the natural world gaining importance. And conservatories aren't just for housing plants any more. They are often temperature controlled for plants and people—and the many different activities that people might enjoy in such a recreational room.

Conservatories are designed to be places of comfort. Of course, there are conservatories for the die-hard horticulturists that have special temperature controls for the growing of specialty plants. But for the rest of us, the environment can be a comfortable, light-filled extension of one's living room, furnished with wicker chairs and needlepoint rugs. Freestanding or attached to the house, conservatories are basically constructed of glass panels with metal tracery supports. The design can match the period style of a house. New technology and construction methods nearly make the glass structures seem without obvious support, so the conservatories are discreet enough to blend with any other structure. Conservatories are versatile enough to fit in tight urban locations, such as second- or third-story attachments, small porch like structures, or even extended window boxes. At night, when darkness falls, the panes of glass catch and reflect the light, and the conservatories become magical jewels in the landscape.

And, you have a choice of what kinds of plants to grow inside. Choose a humid climate for tropical plants. A more temperate climate will support vines or sparmannia. Tiered stands can support plants. Or trellises or wires fixed to the walls can support climbers.

right
Nestle a conservatory deep in your property, away from the house, and it becomes a great escape. Set in the garden and painted blue, the decorative finials and ridge are quite visible, as are the graceful curves of the tracery windows.

the small urban courtyard/alleyways

In an urban setting, townhouses create small, internal courtyards, which are essentially one's backyard. This space is usually enclosed by walls of other buildings, with no spectacular views. Somewhat sheltered from the environment and with a sense of enclosure and privacy, here one can create a simple outdoor environment or go for the fantastic—a Moorish palace or an Elizabethan-style fortress. Create an intimate, romantic feeling with the addition of fountains, exotic plants, subtle lighting. Or be theatrical in your decoration, relying on colors, bold geometrical shapes, and fabrics to enliven the space. Change the décor as often as you wish. A single paving surface will unite the space, while small-scale units like stone blocks, cobbles, and brick will increase the illusion of space.

Urban dwellers can also take advantage of alleyways or walkways between structures. These may be semipublic spaces or private pieces of real estate. Here, sometimes, a simple teak or metal bench surrounded by lush planting makes a peaceful hideaway.

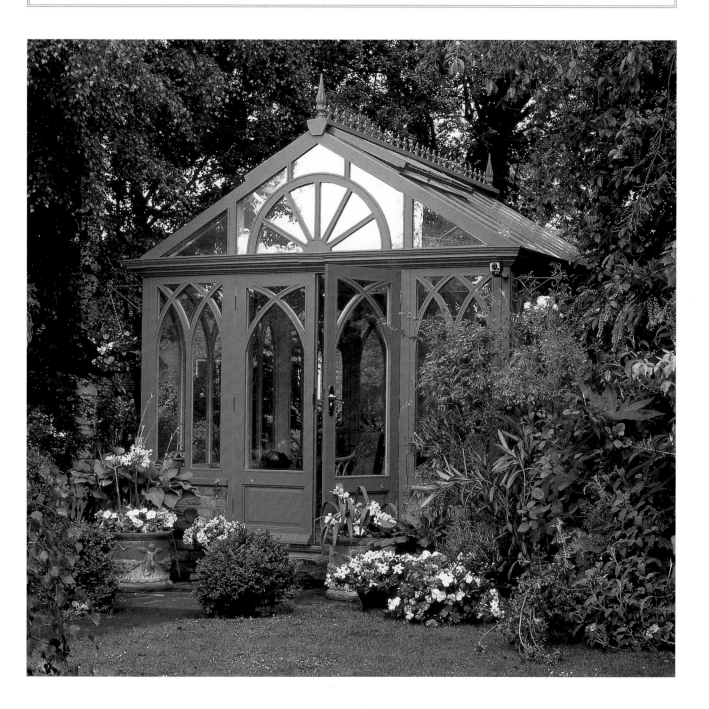

UTILITY BUILDINGS PUT TO USE

In the days of the grand estates, outbuildings were modeled in the same style as the main house and integrated into the fabric of the estate. In modern times, our utility buildings are more likely to be carports, tool sheds, log piles, potting sheds, garages, or compost bins. Many are decidedly unattractive, and we attempt to hide them behind shrubbery or fencing. These buildings don't necessarily need to be unattractive, though, and even the simplest structure, with a little creative thought, can fade gently into the background.

The secret to success is location, size, shape, and color. If a tucked-away corner can't be found, try toning down the color of the building and it becomes a background structure or an edge of your outdoor room. Cover the structure with climbing plants and it will become a beautifully scented addition to your space. Or style the outbuilding to match the design of your house and it is an echo house.

You could go in the opposite direction, and make the building a decorative attraction with brighter paintwork. The utility building can become a genuine focal point of your outdoor room and can even set an exotic mood with a full-sized *trompe l'oeil* image of a tropical jungle.

Consider creative uses for unwanted outbuildings. Old garages can be great office spaces, artists' studios, or woodworking shops. Bring electricity to the building and fix up the interior to suit your needs. Leave the telephone in the main house.

below
Painted a weathered gray, a garden shed fades into the background in the outdoor room. Other elements, such as the Adirondack chair, metal plant containers, and flagstone and gravel paving echo the subtle tonalities and allow the colors of the flowers to decorate the room.

recycled materials

Be environmentally friendly and recycle materials in your outdoor room. Reusing materials can be a remarkably less expensive option than using new materials. The only word of caution is that, if you are paving or doing structural work, make sure the recycled materials are still durable enough for the job.

Visit flea markets, construction sites, and recycling centers for suitable materials. Salvaged and remilled lumber or "barn wood" can frame arbors. Broken concrete can be used for retaining walls or pathways. Stones and bricks from torn-down walls can be crafted into new walkways and patios. Scrap metal can be used to roof a shed. Old reinforcing bar can be twisted into decorative trellises, arbors, or gates. Rusting watering cans, barrels, and jugs can become fountains.

Another advantage to recycled materials is that they add character to your outdoor room. Each project will be unique. You can fill old containers, such as old enamel sinks, cups, wicker baskets, wooden fruit and vegetable crates and packing cases, with plants

above
A wraparound porch is an ideal repository for funky, recycled objects. The rough edges of the more antique elements are softened with colorful throw pillows and potted plants and flowers.

outdoor easy — installing the gazebo or summerhouse

Like potting sheds, gazebos can be do-it-yourself projects. Relatively simple structures, gazebos require a foundation, posts or walls, beams, rafters, and roofing. Height should be at least 8 feet at the highest point and the foundation should be at least 8 feet wide and deep to provide sufficient space for furniture. A traditional 6- or 8-hub style shape is easiest to construct. Pressure-treated lumber will resist decay. Solid roof materials should be pitched to allow water runoff.

Gazebos can, in fact, be quite fancy. Add gingerbread trim from the Victorian era. Try an octagonal or hexagonal shape, rather than a square or round structure. Or have some fun. Hire an artist or an architect—or design your own unique gazebo or small shelter that stands as a piece of sculpture in your garden. Try using unusual materials, such as plywood or stone or twigs. Designate the gazebo as the location for the cigar smokers in the house. Or build the treehouse that you always wanted as a kid. If you are weak of heart, gazebo kits are available.

A summerhouse is a more complicated to construct because you need to prepare a solid and level foundation of compacted hardcore material, approximately 4 inches (10 cm) thick. Over this foundation a concrete base is laid. (Or for a lightweight building, lay wooden bearers.) A summerhouse should be large enough to accommodate several people sitting comfortably, with doors opening out onto a veranda. You can design and make your own summerhouse, or summerhouses are available as prefabricated sectional buildings.

right
Dinner is served under a minimally designed gazebo, which consists of a roof and its supports—and a ceiling fan to move the air and spotlights pointed up into the ceiling for indirect lighting. The gazebo's simplicity is offset by the exotic setting.

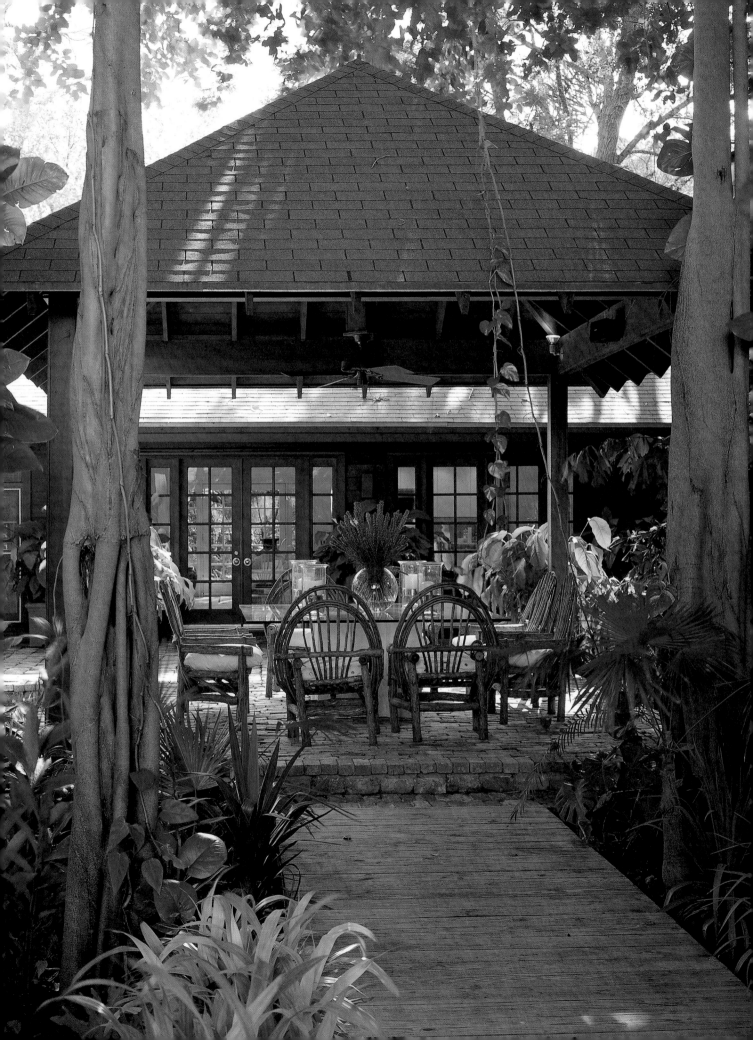

POOLSIDE SHELTERS

Every poolside needs a shelter from the sun. Poolside shelters could simply consist of a fabric umbrella or a vine-covered trellis or be a full-scale pavilion with showering capabilities. Offer comfortable lounge furniture that can easily be moved in and out of the shade and cushion with fabrics that are suited for water saturation. Blue is a favorite color poolside, as are stripes and nautical themes. Lush planting brings an exotic ambience.

Bring a bit of the islands to your poolside. Construct a small building or two, with hipped corrugated-aluminum roofs and soffits cut with hearts, moons, and stars. Whitewash the exterior walls and paint the shutters a nail-polish pink. Or go rustic. If there is a dilapi-

below
The pool pavilion resembles a well-cushioned, rustic hideaway. Seating is built in, while simple wood tables and restrained decoration create a cozy atmosphere under the huge ceiling beams.

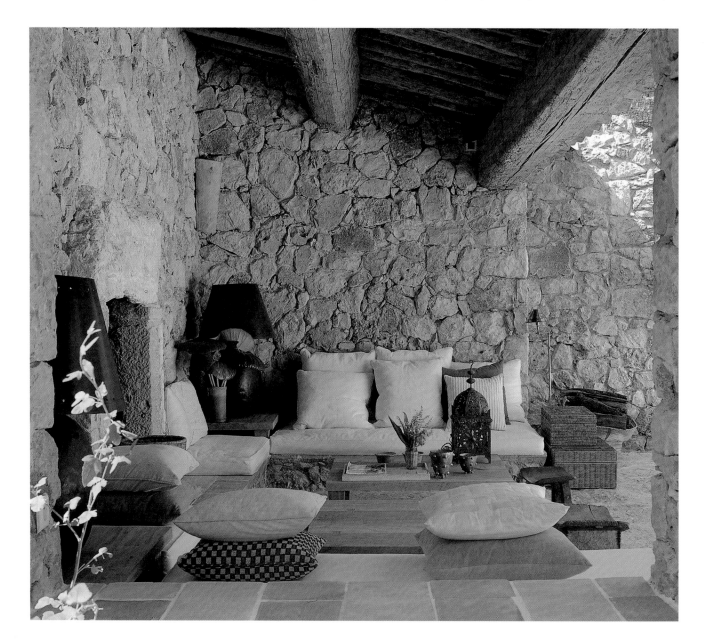

dated barn on your property, renovate it and add a vine-covered pergola. Or build a rustic shed out of rough-hewn lumber and cover it with creeping honeysuckle. Another solution is to go retro cool and acquire an Airstream trailer. An industrial icon of the early twentieth century, the silver metallic, 21-foot-long trailer is considered a prize find and a perfect addition to a contemporary pool setting.

If you are fortunate to live by the ocean or a lake, you may wish to install a seasonal kiosk near the water. Again, this can provide shelter from the sun, or from an unpleasant invasion of insects. Tent-like structures are easy to construct and to store when not in use.

the ubiquitous umbrella

There are three basic essentials to an umbrella: a center pole, ribs radiating out from a hub that slides up and down to open and close the fabric canopy, and, of course, the canopy itself. The difference between the old-style, wire-frame pool umbrellas and the market style is the cut of the canopy. The old-style is dome shaped with a valance that hangs down from the edges and flaps in the wind. The market umbrella is straight from the top to the end of the ribs and typically has no valance.

The size of the umbrella is important. An umbrella should be large enough to provide shade for the people eating at the table below. That translates to a diameter of at least 3 or 4 feet larger than the table. And, the umbrella needs to be completely closed above the table, so the ribs don't catch the side of the table. Whether mounted in a table or freestanding, make sure a base holds the umbrella upright to protect it from toppling in the wind. The base can be a plastic shell filled with sand or a concrete-filled base on wheels. One-piece poles of wood or aluminum are recommended so it won't break. For UV protection and water and mildew resistance, the umbrella should be a fade-resistant acrylic fabric.

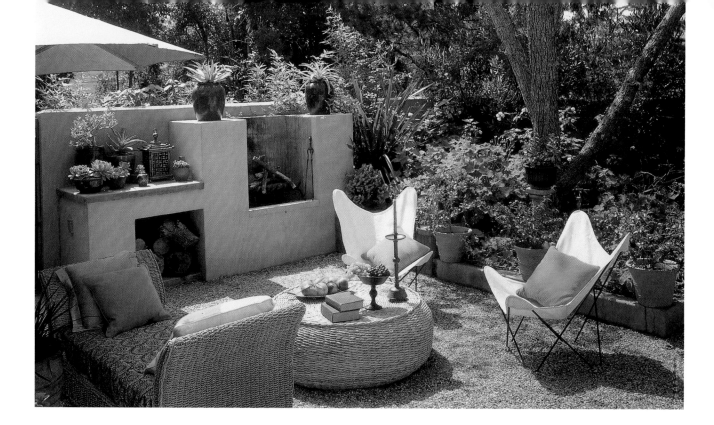

THE OUTDOOR KITCHEN

It's quite common to barbeque outside using a gas or charcoal grill. Custom-built barbeques and fireplaces have a special appeal, especially when integrated into the entire design of the outdoor room. Having access to a full kitchen is a rarer occurrence, yet a kitchen without walls is not unthinkable. In fact, such a room seems quite attractive in temperate climates, where the facilities can be tucked into a porch and at least two sides of the room can be open aired. Another place where an outdoor kitchen makes total sense is poolside, particularly is the pool is a fair distance from the house.

The design of an outdoor kitchen should be relatively simple. A basic stove top will do. More emphasis can be placed on the design of a large oven, which could also double as a fireplace for evening ambience. A source of water and drainage is useful, if possible. Electricity is preferred, especially so work spaces are adequately lit at night. Some storage is needed, but again, the simpler, the better. Work surface space can double for holding prepared food, but be sure surfaces are thoroughly washed between preparing and cooking the food for sanitation purposes. The deluxe model could be a barbeque or stove next to solid counters made of heatproof and waterproof materials, with access to running water. These surfaces are easily cleaned after use. The counters could serve a practical purpose—buffet-style entertaining.

Outdoor cooking requires a whole line of specialty tools—long-handled tongs with a firm grip, a flexible metal spatula, a basting brush, fish-shaped metal baskets, and square or oblong baskets for cooking vegetables.

eating outdoors

Once you've set up your outdoor kitchen—or even if you dine picnic style—you're likely to return often. It's quite pleasant eating in the fresh air in your outdoor room, in the dappled sunlight, in the flickering of candlelight, or under the stars. If only you had a little bit more room and the barbeque smoke didn't keep getting in your eyes. Seriously, consider these design tips as you plan you outdoor eating area.

Size: Consider how many people will be dining there. Even measure the dimensions of your dining room to figure out the amount of space you'll need to set up a table and chairs.

Shape: Make sure your patio or terrace or deck is shaped properly to handle a conventional round, square, or rectangular table. If it isn't going to be, you should know before construction.

Location: Your barbeque or grill needs to be located near enough to your eating area so that the chef (the host or hostess) can remain connected with the guests and analyze wind currents—you don't want to smoke out your guests.

Power: Do consider the electricity you'll need to provide adequate light to the cooking surface. You'll need more light to cook than you will when dining. When dining, you can use low-voltage lights, torches, and candles.

Simplicity: You don't need to bring out your best china, but you don't have to go for the white paper plates and white plastic forks, knives, and spoons. There are practical, inexpensive, but well-designed outdoor utensils and plates that will add a bit of style and ambience to your outdoor celebration.

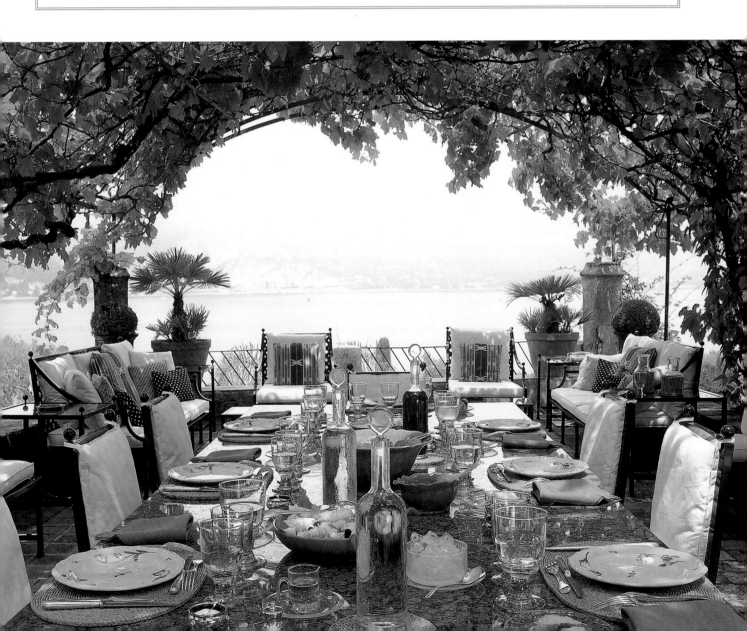

INDOOR/OUTDOOR
ROOMS

The ideal temperature for indoor/outdoor living ranges between 68 and 80 degrees Fahrenheit (20 to 27 degrees Celsius), with low humidity. Under such conditions, it is easy to move between inside and out without noticing a drastic change in comfort. In fact, having large interior expanses open to the exterior is preferable for it vastly extends one's living space. Besides, there is the additional benefit of a daily connection with fresh air and natural light.

In reality, few of us live in that ideal climate—or at least enjoy countless days like that. But don't despair. There are many ways to bring the outdoors in. There are also many devices to make the outdoors more comfortable when nature isn't actually offering the perfect day, or the perfect setting. For instance, sunrooms and conservatories are excellent choices in colder climates to brighten up your house on a dreary winter day. Decorating these rooms as you would an outdoor patio or a porch with wicker or metal furniture maintains the freshness of summer all year long. And the extra amount of light filtering in the large windows and warming the rooms will remind you of a lovely summer afternoon. The light will be so strong that your summer plants can survive over the winter inside. When necessary, glare from the sun can be controlled with blinds, shades, or curtains.

The reverse problem is too much sun and glare outdoors. Nature provides the best source for shade in deciduous trees, but, obviously, it takes years for an oak or elm tree to mature. Other options include the many structures discussed in early chapters, such as trellises, gazebos, arbors, and porches, over which plants will climb and provide shade. Add to that list what I call a sunhouse, a small, screened-in pavilion designed just for protection from the sun, wind, and other elements. On open-air platforms, fabric, such as muslin curtains or canopy, can serve as sunscreens to regulate the amount of natural light entering a space and, when in use, to act as a cooling mechanism. Canopies also add festive colors to a setting. As protective covering, canopies made outside spaces seem inside.

right
This trellis like structure makes this screened-in porch seem more outdoors than in. Natural light easily flows through the screen walls and translucent ceilings. The warm air is moved by a ceiling fan in a room that offers multiple ways to relax.

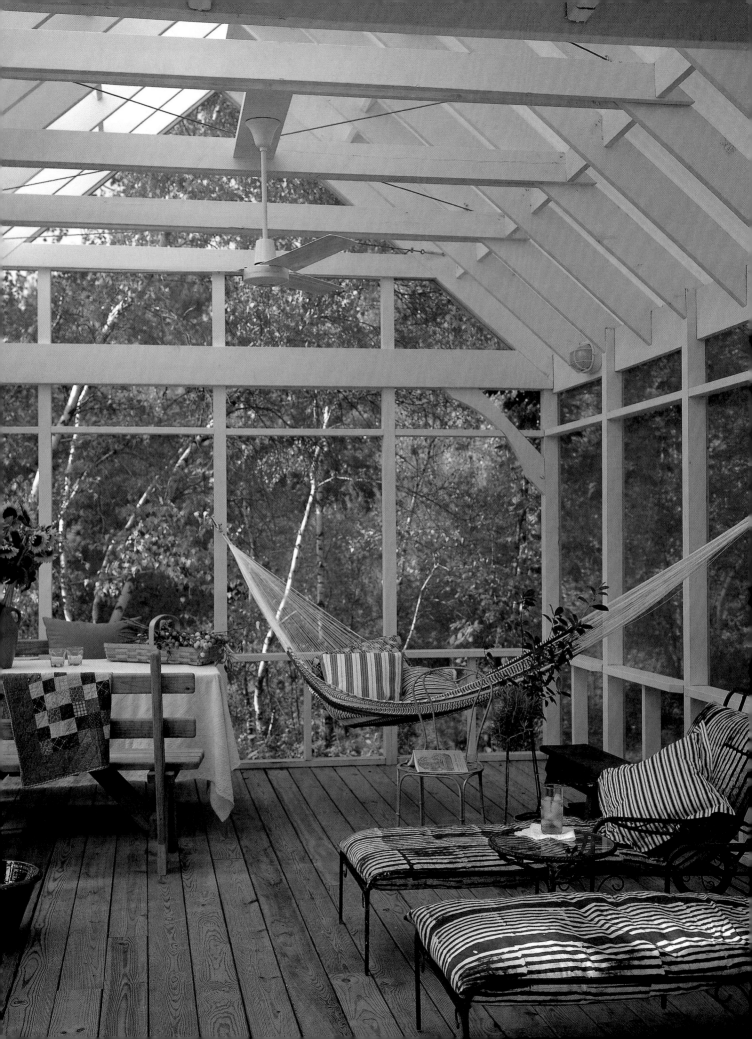

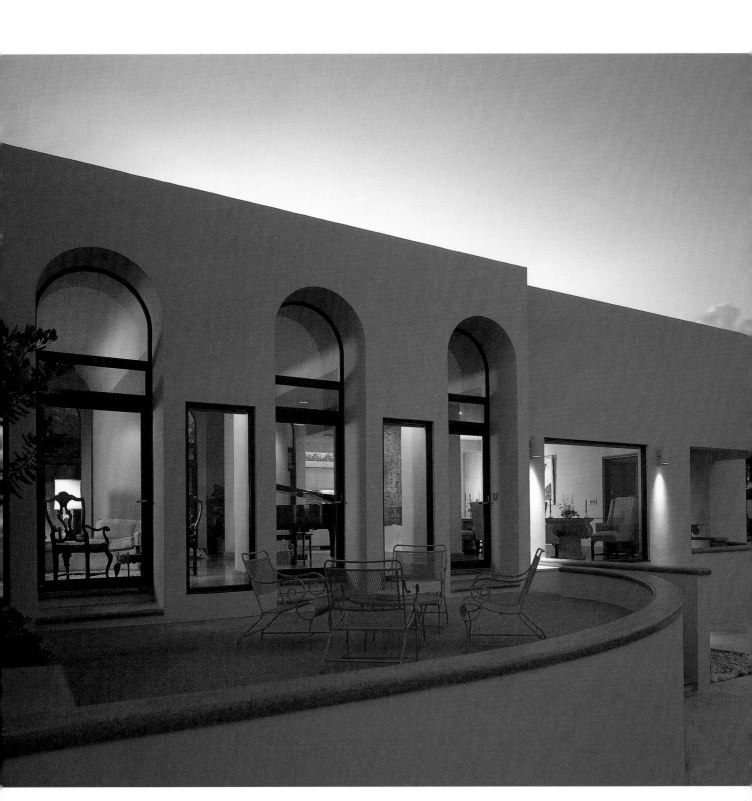

above
At dusk the interior spaces of this modern house seem to
flow out uninterrupted to the terrace. Huge window openings
and soft lighting heightens the illusionary effect.

INDOOR/OUTDOOR ILLUSIONS

French doors and floor-to-ceiling windows establish an uninterrupted visual flow from indoors to outdoors. That fluidity can make two rooms into one, even if they are separated by a glass wall! Obviously, the French doors open onto the outside room— a delightful bonus and one that truly unites inside and out. The concept is all about extending space. There is no reason why the connection can't be made year round. A pristine snow fall is a lovely sight when you are snug and warm in your garden room. On the other hand, in the middle of the summer it is nice to extend your cocktail party from your living room through your dining room out your French doors onto the terrace and further into the garden. Or in the temperate zone, consider full-height shutters that can be opened each morning to the central courtyard, thus blurring the lines between inside and out.

When planning a new outdoor room, consider access from the main house. This is an important connection. If awkward, it will affect the flow between inside and out. And while you may not be anticipating any new construction on your house, you may realize that the creation of a new door—or the enlargement of an existing door into a French door—will greatly expand your outdoor options. In other words, the transition between inside and out is highly significant in design terms.

making the transition

If the main purpose of your terrace is for dining at night, it would be awkward if the access were only from the kitchen through the dining room but also through the living room. Plan to go directly from the eating areas, if possible. Therefore, early planning—matching function with location—will, in the long run, prove worthwhile. And there will undoubtedly be some transition from inside to out, even if it is only a threshold. Treating this threshold with materials similar to the interior brings a unity to the entire composition. For instance, the flooring material is a starting point. Just echoing the texture or color of the floor may be enough to establish a connection. Or choose paving for the threshold that matches the exterior materials of the house. Then you can switch to a different material for the rest of the outdoor paving. Also make sure that the entrances are wide enough to accommodate your needs—i.e., the flow of people through the door during a party.

outdoor easy —
bringing natural light in

Bringing the outdoors in involves structural changes to your house, unless you already have a sunroom or a porch. In northern climates, a southern orientation is preferred, and in southern climates, a northern one. The ideal construction should utilize as much glazing as possible, with the opportunity to open the windows to the fresh air. Through the glass, the incoming sun will provide healthy natural light, as well as outgoing views into the garden, which can provide a calming connection to nature. Even if the sun isn't shining or there are overhead shade trees, solar heat will be transferred into the room.

Choose flooring accordingly, for solar heat can be stored and released in the evening. In some cases, designers will make special efforts to harness this solar energy. Additionally, skylights are an excellent device for opening a room to light and can be placed deep within a house. Or try a cathedral ceiling, placing glass in the eaves and opening up the entire room to natural daylight.

Many types and styles of insulated windows are available. Manufacturers offer windows in all shapes and sizes and also windows that are designed to specifically deter solar heat gain. Attractive systems of blinds, shades, and curtains also help. Try blinds that automatically open and close, depending on the time of day or the orientation of the sun.

If tearing down the walls of the house isn't an option, there are less costly ways to brighten an interior room—to make it feel like a sunroom. Take down the heavy curtains or blinds and replace them with shear window coverings to allow as much natural light as possible to enter. Strategically hang a large, decorative mirror on a wall to reflect that natural light around the room. Or hang a couple of mirrors that can bounce light back and forth. Paint the room a bright, light color that reflects the sun. White or off-white is an obvious choice, but even consider yellow. Bright yellows make a room appear lighter by simulating sunlight. And, depending on the yellow, it can make a very large room feel cozier. Yellow is best where more energy is desired, as well as to provide a cheerful atmosphere.

right
Add a light, airy sunroom to the perimeter of your house. Special solar glass, as well as a ceiling fan, can help reduce heat gain. This cheerful, sunny room is an attraction in the gloomy winter.

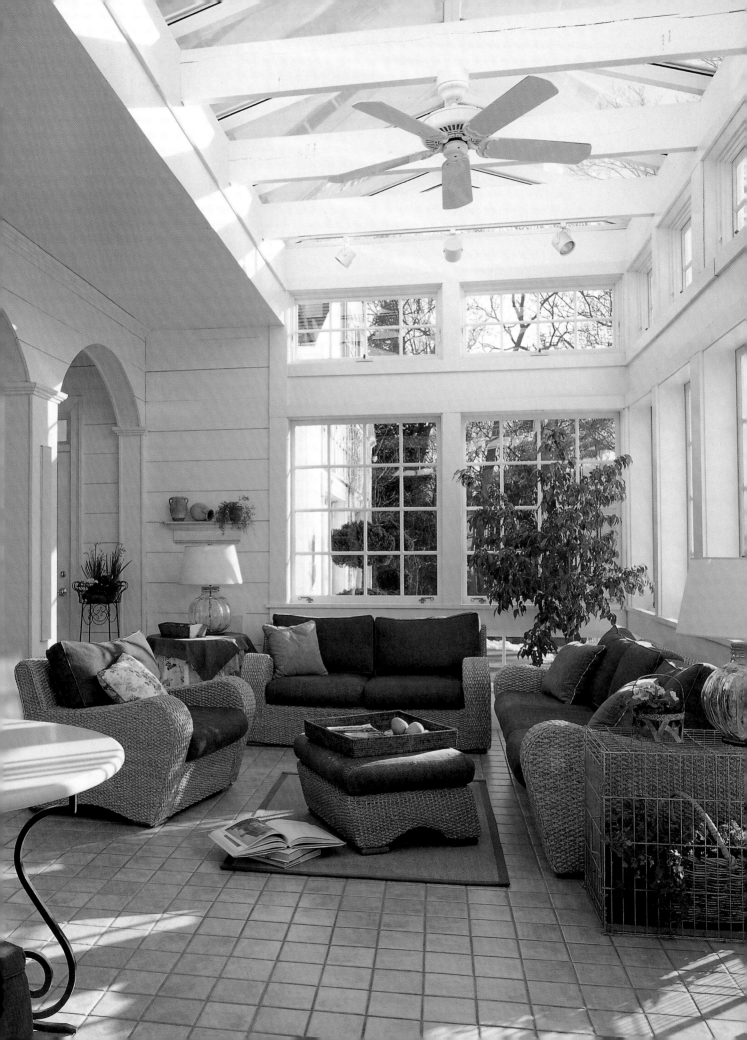

CONTROLLING NATURAL LIGHT/INDOORS

You've successfully brought an abundance of natural light into your sunroom or porch— too much, in fact, on those hot, sunny, summer days. Your first inclination is to close all the windows and turn on the air conditioner. There are other options to try first—ones that can actually be considered environmentally friendly, and save you money on your energy bill. Think about blinds, shades, and shutters. You could also consider curtains, if you choose either a thick fabric one with a curtain liner to help block out the sun. Curtains, however, often play a more decorative role, providing a softness and color around the windows. Blinds, shades, and shutters really do the trick and shut out direct sun light and glare by tightly covering the entire window surface with the pull of a string—or in some cases, the flip of a switch.

below
The high ceiling of the Victorian porch allows an abundance of natural light to enter. It is filtered somewhat by the exotic plants and the decorative panes in the windows.

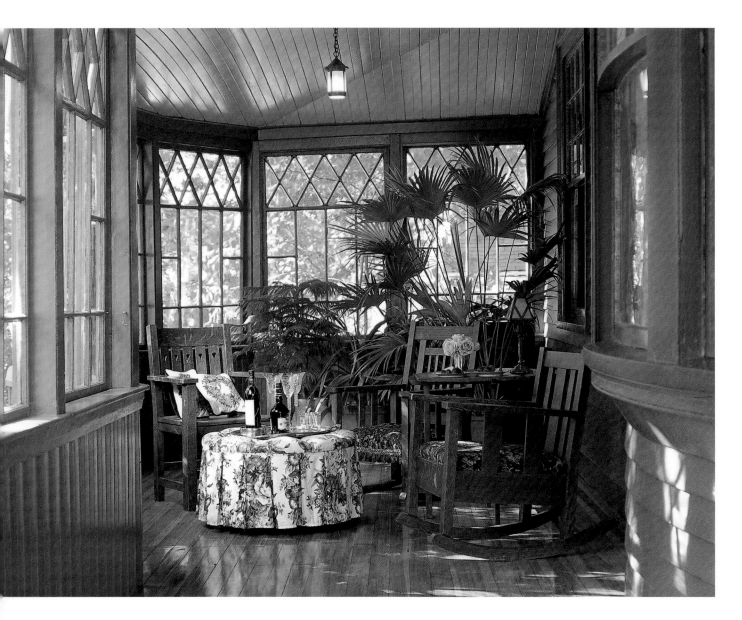

Blinds and shades are actually lowered and raised (or pulled to the side) by a spring mechanism or a cord system. This allows the blind or shade to lie flat against the window, to be gathered, or to be pulled up in folds. Some blinds are made of slats that can be opened and closed to regulate light intake. Here is a brief survey of the different types of blinds, shades, and shutters.

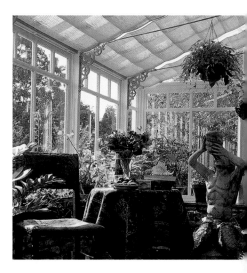

above
Wooden slatted blinds are pulled across the ceiling of the conservatory when necessary to control natural light and glare. The tan blinds blend well with the similarly colored stone floor. The conservatory is arranged for quiet contemplation.

Venetian blinds: Come in a huge range of styles and materials—slats of wood, plastic, aluminum, or vinyl in a variety of colors and finishes, suited to both traditional and ultramodern rooms. Venetian blinds with very narrow slats, known as miniblinds, are ideal for locations, such as large expanses of glass, where an unobtrusive window covering is desired.

Vertical blinds: Based on the idea of louvers—slats that are angled or close out light, but these are hung vertically and drawn side to side. Ideal for patio doors.

Woven wood shade: Horizontal slats of wood woven with yarn in a variety of patterns. Pulls up in folds.

Matchstick shades: Slim splits of wood sewn tightly together with thread. They roll up.

Pleated and cellular shades: Permanently accordion-pleated fabric shades that diffuse light. Double layer of pleated fabric, producing small air cells that insulate against cold and noise.

Balloon shades: The shade is pulled up and let down in a series of gathered, scallop-like folds. When the shade is completely down, the only fullness remaining in the length is at the base, where it is still gathered.

Austrian shade: Like a balloon shade, but has the fullness distributed along its entire length.

Pull-up shades: Like balloon shades, but are made to lower to the floor.

Roller shades: Originally manila-colored shades, they can be painted, stenciled, and made in several different kinds of fabric—and can be plain or highly decorative. The shades are wound around a roller that is controlled either by a cog or spring mechanism.

Reverse roller shade: The rolled fabric is at the bottom.

Roman shade: A flat shade with no fullness across the width. When pulled down, there is no fullness in the length, either.

Shutters: Can be louvered and folding, the old solid variety. Painted any color or stripped.

CONTROLLING NATURAL LIGHT/OUTDOORS

Controlling natural light outdoors takes a bit of imagination. After all, there are no windows to cover, as there are in a sunroom or porch. Blocking the sun's rays falling through open space becomes a more difficult challenge—but not impossible.

Begin by first mapping out the sun's movement in your outdoor room. Most likely, the greatest need for the coolness of shade will be a warm summer afternoon. Note, though, that strategies for reduction of glare might pinpoint a different time of day, depending on the elevation of the sun. Ask these questions: Does the temperature in the outdoor room soar at a certain hour? Is there a specific time when the glare is particularly uncomfortable? The objective is to filter or block the sun's rays yet keep the air moving through the space.

Consider the framework of your outdoor room. Is it suitable for hanging shear muslin curtains? Can you set up a temporary frame to support lightweight curtains? Would bamboo blinds be appropriate? Is the problem that there is no overhead shade—i.e., do you need to install some kind of overhead canvas like a canopy or an awning or perhaps a vine-covered trellis? Canvas and other fabric used for curtains can add festive colors to your setting. Go a step further and erect a pergola or summerhouse.

the circus is in town

Before the days of central air conditioning, canvas awnings donned the windows of houses. When the rains and winds came, at least the windows could be left open, without fear of too much water entering. Now, in the summer, we simply close the windows and turn on the air conditioning. Yet, the canvas canopy—the same material used in circus tents—is quite a viable outdoor domestic shelter. If a terrace or patio located adjacent to the house, a canopy can be attached to the wall of the house and create an outdoor room. This method becomes a particularly useful escape when heavy rains come. Or, you can set up a canvas tent in the yard. And the canvas has taken on another modern role—that of the table umbrella, which comes in different colors and in stripes.

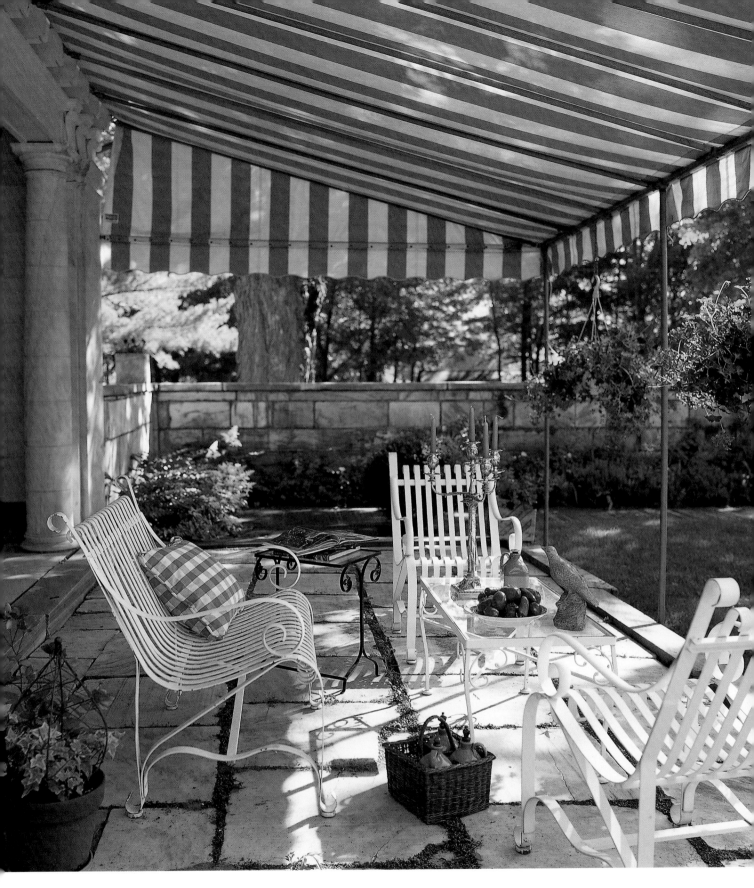

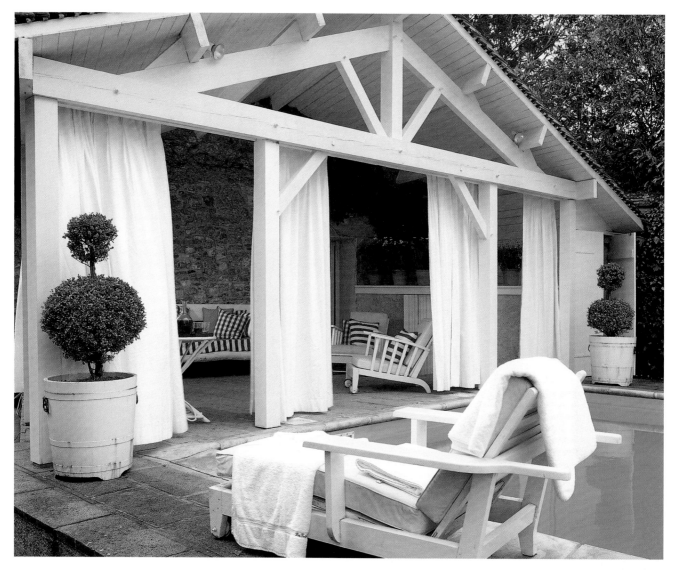

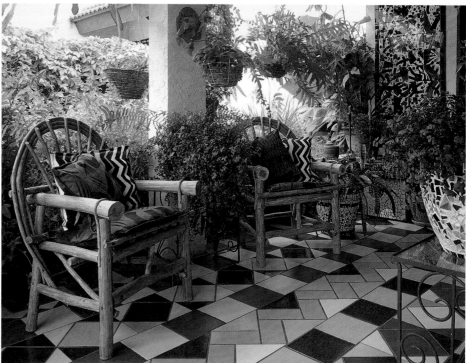

above
Add curtains to a pool shelter when privacy is needed in the outdoors. In other words, quickly shift outdoors indoors, while allowing soft breezes to flow through. The red striped cushions inside the pool pavilion add a bright flash of color to the serene setting.

right
Colorful floor tiles, rustic chairs, ceramic pots, and hanging plants camouflage the location of this room. Is it inside or out? Or in between?

CREATING INDOORS OUTDOORS

Comfortable outdoor living is a luxury that is easily attainable. If an open-air experience is not what you have in mind, create indoors outdoors. Perhaps most crucial will be the sense of a roof over your head. Many options exist—build a structure, like a summerhouse or gazebo. Add an arbor or trellis covered with climbing plants. Raise a canopy.

Perhaps, though, an overhead enclosure is not the issue, but you desire a space outdoors that is as complete in its design as any indoor room; that would bring you long-term enjoyment and comfort. Each solution will be unique as your site and climate are, as well as your particular stylistic yearnings. What you need to do is furnish and decorate your outdoor room with imagination.

Experiment with some of the suggestions and ideas found here in *Outdoor Decorating and Style Guide*. Try a bit of whimsy. Or indulge in the exotic. Most important of all, don't be afraid to connect with nature and to enjoy the passage of each day and each season outdoors.

bottom
Enclosures define our sense of space. Create your own with a system of curtains set on metal rods, as seen here surrounding a pool and terrace. Blowing in the wind, the curtains take on a ghost-like appearance, but work effectively at establishing the boundaries of the outdoor room.

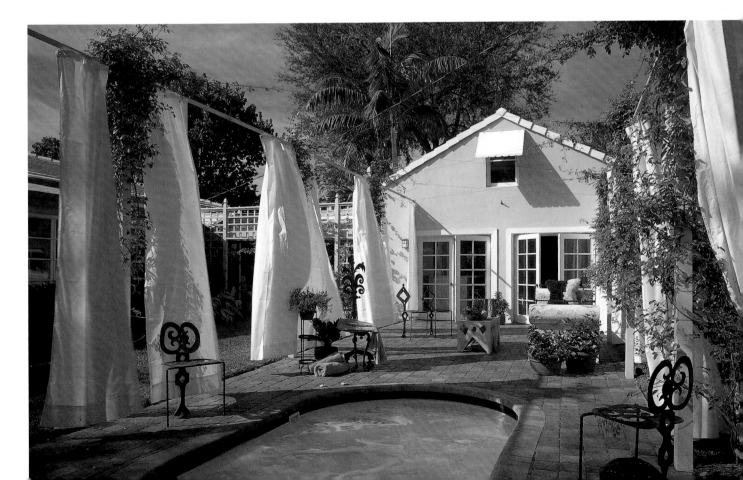

OUTDOOR STYLE:
SIX PERSPECTIVES

Arn Ginsburg
GINSBURG HOUSE

This condominium fools the eye. The building perches atop a hill, although you might think you're high up in the mountains far away from the city. It is also deceptively small. The 750 square feet of interior floor space seems much larger, thanks to the central courtyard, the minimalist furnishings, and the absence of clutter.

Arn Ginsburg owned and designed the space, one of four condominiums in a building above a parking garage, which he then occupied for several years. The site posed some special challenges. The lot's substandard width and elongated shape, combined with a diagonal slope, made it a difficult building site. And the unit's location over the parking garage made weight and leaks an issue. Ginsburg accepted the challenges with imagination, and created a unique and livable home.

The floor plan is inspired by traditional Spanish courtyard houses. Eighteen movable doors cleverly fold into storage closets surrounding the central space, which is open to the sky. When completely open, the house is a spacious and inviting place. By closing various combinations of doors, one can devise a variety of room configurations. Inexpensive, lightweight indoor/outdoor carpeting covers all of the floors, over a cushioning pad inside and a waterproof barrier in the courtyard to prevent leaks into the garage. "Dirt was never a problem," says Ginsburg. "You just vacuum all the floors and you're done."

above
In this open air room the absence of clutter and
soothing tones calm the spirit.

All of the cabinetry was custom built to fit the space. The galley kitchen is a model of space-saving ideas: a pair of two-burner stoves along the wall have counter room in front of them. Two under-counter refrigerators are less bulky than one large unit. The entry wall hides storage closets, and there is more storage in a downstairs laundry room.

"There are no dark corners," says Ginsburg, thanks to a skylight in each corner. He put a speaker in each skylight too, "so you could always hear the stereo when walking down the hall."

above
Simple furnishings enhance the spaciousness of this courtyard house. Here, one can bathe, or dine, or rest in utter privacy, yet feel completely outdoors.

In keeping with his minimalist taste, Ginsburg used only black sheets on the bed, to contrast with the subdued taupe and white walls. To work, he'd set up his drawing table facing the courtyard. "I never knew there were so many birds until I lived in this place," he marvels. Remarkably, no birds ever flew inside the house in the years he lived there.

The furniture Ginsburg designed is perfectly suited to the house: a system of black laminate-covered plywood pedestals and oak tops can be configured in a seemingly infinite number of ways. Each pedestal has 1-foot, 2-foot, and 3-foot sides. Positioned 3 feet high, a pedestal

becomes the base for his drawing board, where he stood to work. At one foot high, it serves as a coffee table. A pair of two-foot-high pedestals with their oak tops becomes the dining table. Even though Ginsburg now lives elsewhere, he still uses—and loves—his pedestals.

As a designer, Ginsburg cares deeply about courtyard houses. He has designed a lot of them, although not all have been built. He says, "With courtyard houses, you have a sense of spaciousness and privacy. You get an expansive feeling, a sense of elegance." He envisions the courtyards as completely private rooms, and the ideal ones are not spaces that people can peer into from nearby higher buildings. "You can enjoy them in the nude, if you like!" And, he points out with practicality, "There is no lawn to keep up."

Of course, one could argue that it takes a certain climate for this kind of house, although Ginsburg will point out that courtyard houses are nothing new. The Romans had them, as did the Greeks. That icon of modern simplicity, Mies van der Rohe, designed them, and Ginsburg thinks it's high time the tradition was revived. He ponders the mentality that makes people shy away from embracing outdoor living spaces, and hypothesizes, "People like parking their car and stepping right out to the kitchen, rather than into a courtyard and then into the house. They don't think the outside space matters as much as the interior space."

When contemplating Ginsburg's ideal home, Mies' famous dictum, "Less is more," comes to mind, for here he has surely created a simple, neutral space with its own honesty and integrity. Then Ginsburg waxes nostalgic: "That house was the best place to be sick! With the birds, fresh air, sun—a day in bed with a cold hardly seemed an inconvenience at all!"

Ann Knudsen
MAGGIE TAYLOR HOUSE
(GARAGE HOUSE)

The vacation house that Lockwood de Forest designed and built for oil executive Reese Taylor and his family in 1937 is so perfectly suited to its era and its sandy surroundings that designer Ann Knudsen refused to do anything to it that would change its structure or character, even when the current owner, Reese's daughter Maggie, asked her to replace its signature "garage door" with something more conventional.

"It's brilliantly designed," Knudsen insists. "It's a phenomenal house that was totally built for that location." Even though the heavy door wears out every few years, Knudsen convinced her not to change it.

Knudsen points out that while the house may seem impractical—it has no insulation and little storage—it wasn't designed for year-round living. The Taylors wanted a beach-front home for enjoying the ocean and entertaining; that is exactly what they got. What the house *does* have is copper showers that open to the outdoors, phenomenal views out every window, breezy access through the wide garage door, and a truly nautical feel. It also has a patina that Taylor and Knudsen wanted to keep because, above all, it's a family house full of memories. That beautiful "stain" on the walls is nothing more exotic than age, created by the progression of time and lots of loving use. And it's staying right where it is.

Knudsen maintained de Forest's theme of easy beach living. She reupholstered the original furniture with durable fabrics that can withstand wet bathing suits, and took down drapes to let the spectacular views back in. There is very little on the walls, just one or two paintings done specifically for the house; nothing to detract from the views, which are the real art. Knudsen replicated the original fish-scale-patterned linoleum, which is easily cleaned, and left untouched the widely spaced floorboards—through which sand can be swept away.

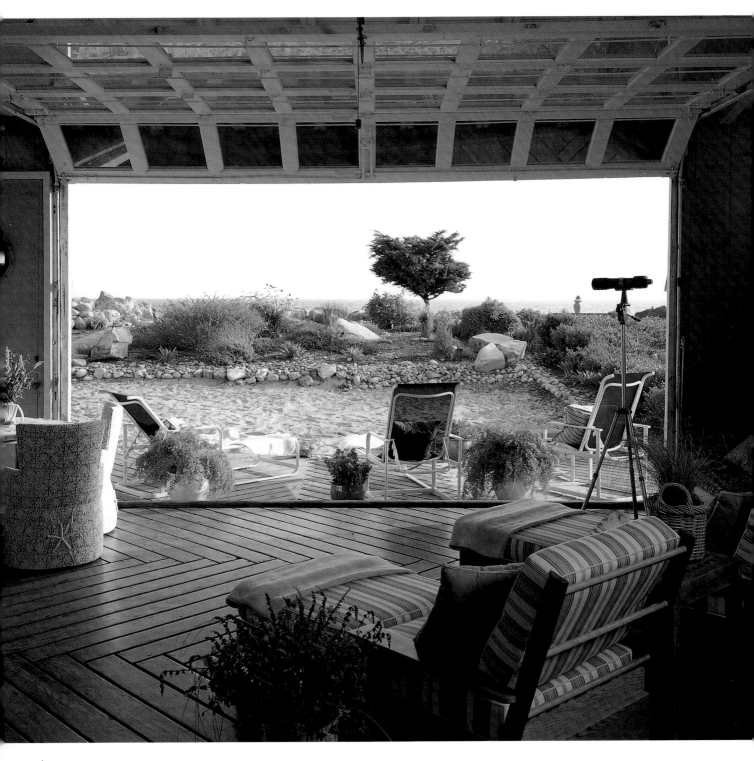

above
This home's unique garage door opens the living
room right onto the beach—perfect for entertaining
or lounging.

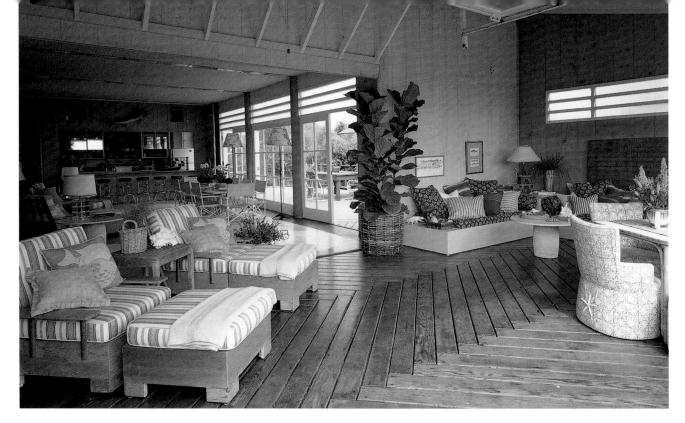

"God is in the details," confirms Knudsen. And this house is swimming in them. So smitten is she with de Forest's comfortable maple furniture that she's reviving and reissuing the line.

Even though the focus is on entertaining guests and the outdoors, there are three bedrooms, as well as a nursery and a servant's pantry. One bedroom looks toward the mountains. Another bedroom, dubbed the "fish room" by Knudsen, because of the vintage blankets on the bed, is just one more reminder that you are at the sea shore. Portholes from the set of *Mutiny on the Bounty* serve as windows. But the pièce de résistance is the master bedroom. Perched on its raised high bed one can see only ocean, sky, and distant mountains, as if surveying the landscape from inside a steamboat pilothouse.

"It's like living on a ship," says Knudsen. "You have to walk outside to get from one end to the other." What better house to reflect a family's aquatic passion?

Ann Knudsen specializes in spaces that combine outdoors with indoors. Many have walls of glass or decks over steep canyons, but whatever their milieu, she makes sure the living spaces are intimately matched to their surroundings. For the "garage house," she had in mind less a makeover than to make the house look as if it hadn't been decorated at all. "That is the spirit of the house," she says.

It seems she met her goal. One day Knudsen took de Forest's son to see the house, curious to learn his opinion of her remodeling. After a tour, he paid her the highest compliment she could imagine: He said his father would approve.

Kelly Wearstler, KWID
KORZEN HOUSE

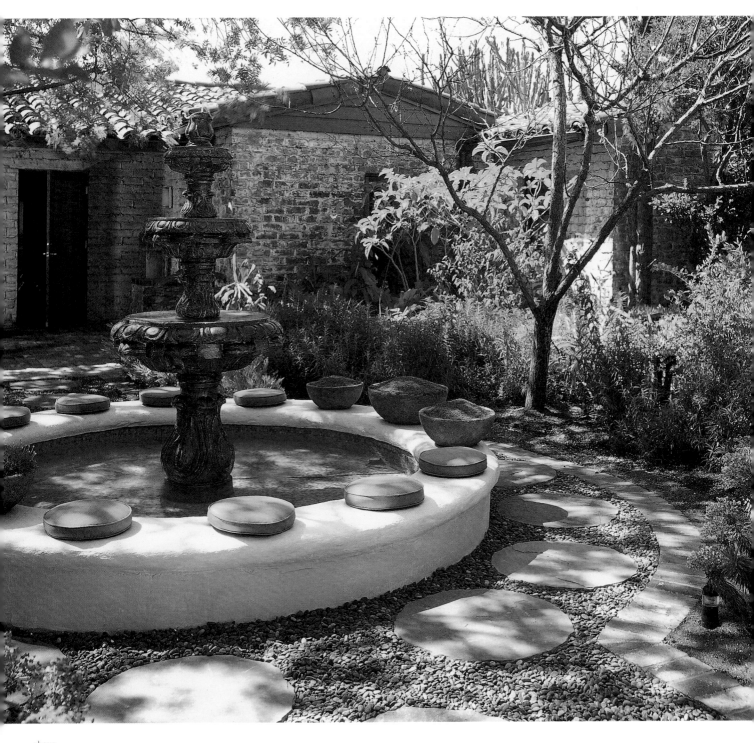

When the Korzens decided to renovate the outdoor space at their Hollywood Hills home, they knew the result they wanted: An outdoor living area that included a variety of places for enjoying the view, swimming, barbecuing and eating, and entertaining guests. This is the introduction people have to their property, because they enter the walled space, pass by the pool and garden, and then enter the house, so the Korzens wanted it to be special.

"We had the pleasure of a wonderful existing layout to work with," says landscape designer Mia Lehrer. "The space was overgrown, but we kept the basic elements, like the semicircular courtyard and the three-tiered fountain."

The home is Spanish style with a modern interior; the designers carried that theme outside. Lehrer and Kelly Wearstler of KWID juxtaposed traditional Mediterranean landscaping with modern furniture to create something entirely fresh and new, yet with Old World flavor. They added terraces and new mahogany doors with glass panels that open into the garden. They painted the original fountain a playful bronze, and added textured green and purple *bissiza tile* inside the pool for visual interest. Modern glazed tile decorates the barbecue. Contemporary angles and smooth edges define the pool area. The red Arizona flagstone is new, but the edges are random, a very Mediterranean detail. Gravel pathways connect the different areas.

"The idea was to not add more concrete, which is hot," says Lehrer.

Tall-back, black rattan chairs add a sweep of modernity, yet seem right at home with the weathered brick. The designers echoed the circular pattern of the courtyard with the fountain pool, round cushions, and other elements. Wearstler paid special attention to the lighting, adding dramatic uplighting to the old cypress trees as well as inside the pool, and dotting chandeliers throughout the area, near the barbecue and elsewhere.

Lehrer selected plants that were popular in the 1940s, plants that would have been used when the house was new, including aloe, ginger, philodendron, sage, and honeysuckle. The way she used them is distinctly contemporary, however: One plant with an interesting structure is positioned in each exquisite pot. Other plants, such as bird of paradise, were selected for big sweeping effects.

KWID's projects include hotels, cabanas, and other interior spaces where guests are made to feel as if they are outside.

left
Modern rattan, weathered brick, and a sculptural plant juxtapose old and new in a welcoming outdoor space.

Carla Cormany
CORMANY HOUSE

Carla Cormany knew exactly the look she sought for her home—a rustic, Latin influence to house her collected treasures. To accomplish that, she assembled tile, wrought iron, twig furniture, hand-carved fountains from Guadalajara, brick laid in a traditional herringbone pattern, bright paint, and colorful flowers into a personal and welcoming outdoor environment.

"Outdoor spaces are very important to us," she says. Carla and her husband love to entertain and barbeque. A typical evening might include cocktails in the front courtyard near the fountain, beneath the yellow and orange trumpet vine, followed by dinner outside in the back. Low walls keep the coyotes and rabbits out, but are low enough to reveal the stark piñon and juniper beyond. "I gave the outside as much thought as the inside," she says.

Even though the renovation is new, she wanted the space to look aged and lived in from the outset. Toward that end, Carla paid extra to have the thirty-three thousand bricks tumbled to remove their hard edges and sharp corners, and used real stucco, rather than synthetic, because she wanted the hairline fractures that most people think are flaws. The hand-troweled stucco is "as smooth as could be." Inside the house, she insisted on a unique mud plastering technique. Its wavy edges may seem imperfect to some, but the resulting walls are like suede, with a depth of shading that is impossible to achieve with mere paint. There are fifteen sets of antique Mexican doors throughout the house, aged copper details, and antique light fixtures. Even the beams were treated with a fertilizer-like composite to make them look weathered.

right
Traditional mud-plastered walls and Mexican tiles meld beautifully with the iron chairs and pedestal table. The candle light fixture above is antique.

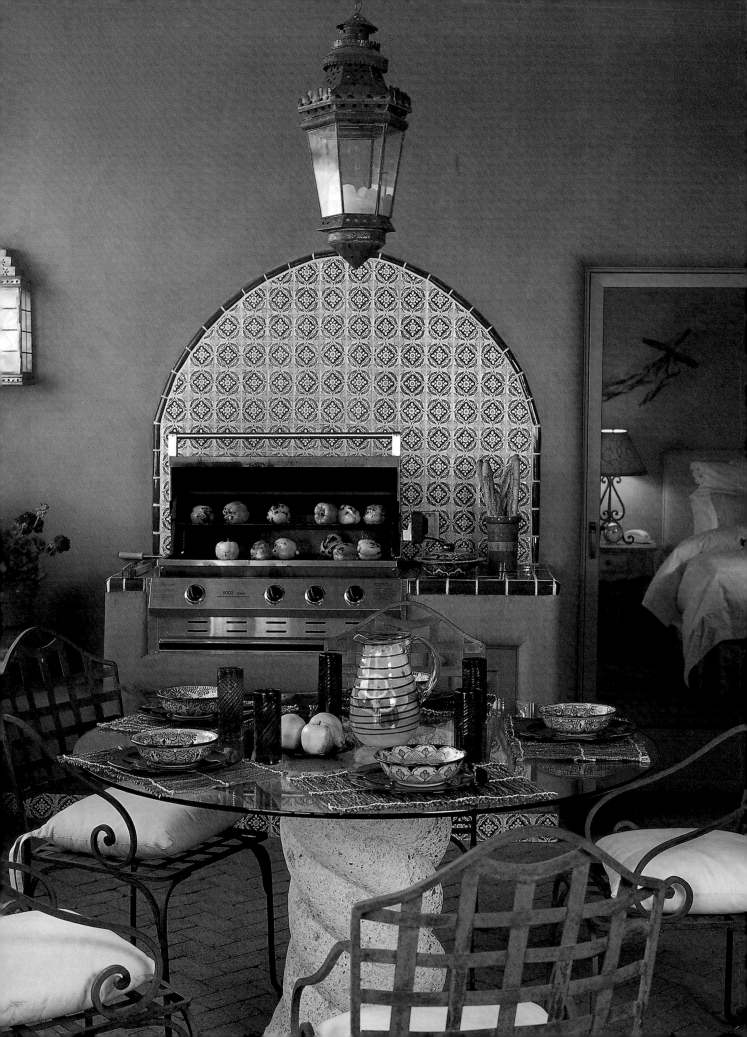

Everything about the house is oriented to the outdoors. The bedrooms open to the outside. There is a long *banco* for extra seating. "I always upholster my outdoor furniture in stark white," Carla notes. "It looks clean and crisp." Other surfaces feature Mexican pigskin, which does well under cover outside. Little windows cast deep geometric shadows in the brilliant sunlight. The cosmic blue color trimming the doors and windows is believed to ward off evil spirits. The hammock is a flea market find. Old serapes serve as tablecloths or as throws to keep legs warm in the crisp, cool evening.

Carla contrasted the starkness of the landscape with colorful blossoms inside the walls, planting pots of annuals and lots of perennials in the yard: daylilies, Russian sage, oriental poppies, jasmine, Virginia creeper—anything that would cover and soften the walls.

Today, the Cormanys live in an old mud adobe house. It has an outdoor kitchen adorned with Mexican tile. Carla commissioned a local artist to paint a mural over the cooktop. The Cormanys are soon moving to Hawaii, where Carla will renovate an old pineapple plantation house, and, no doubt, enjoy finding new ways to bring the indoors out.

Ken Ronchetti/Ronchetti House
DUCKET HOUSE

The challenge that faced Ken Ronchetti when he designed the outdoor spaces at the
Ducket House quickly turned into an opportunity. Inspired by the fishermen's cottages
he'd seen in Sardinia, Ronchetti transformed the sloping property into a series of terraces
connected by bridges and gardens. He oriented the multilevel spaces to take advantage of
the prevailing sea breezes, while keeping the dining area in shade during the 90-degree
daytime.

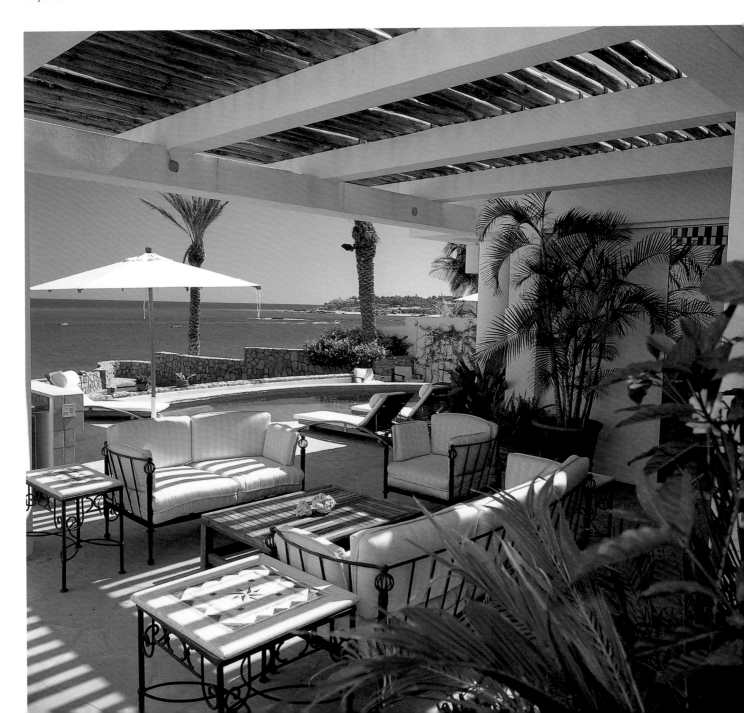

The relationship of the outdoors to the inside of the house developed from the form of the house itself. All of the sleeping and living rooms have shutter like teak doors to the outside, which slide into their own "parking spaces." Clever screened shutters on the windows stack on the inside of each room. A glass wall in each bathroom opens so one can "bathe outdoors" in complete privacy. Ports ventilate the roof and a veranda prevents the tiles from soaking up the heat of the day. Ocean breezes keep the house so comfortable, in fact, that the owner moved the air conditioning to a guest house. Even the teak furniture helps the indoors and outdoors meld into one, for it can be used in either place. In reality, Ronchetti says, "You could live here as though there were no glass."

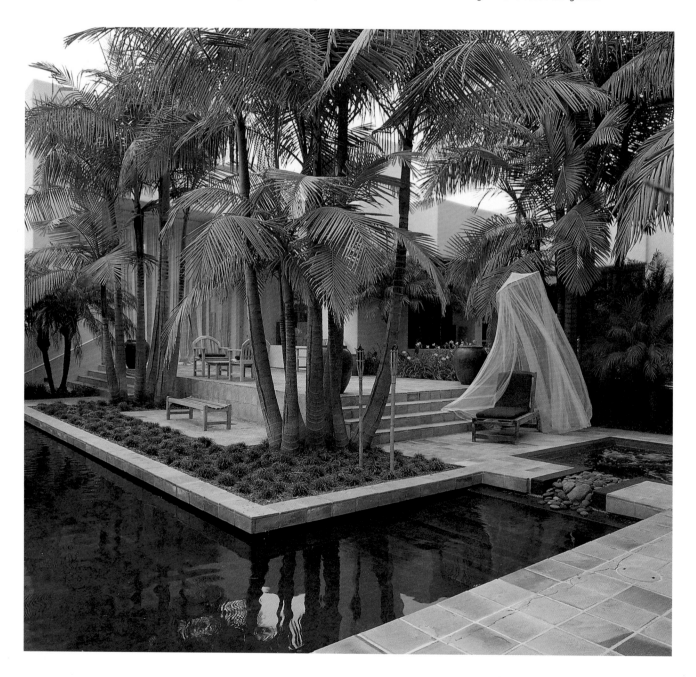

Ronchetti applied the same affinity for outdoor spaces to his own home, where gauzy drapes add a theatrical flair to the fireplace and decorative pools. "The gauze is practical, too," he notes. "It keeps the birds from flying in."

His design philosophy is simple in theory, but not that easy to accomplish.

"Pay attention to the owner's delights," he says, "and to the spirit they bring to their house."

He has built outdoor rooms for houses in places like Colorado, with huge courtyards and massive outdoor fireplaces. "It's beautiful in winter," he notes. "It's actually high desert and dry." Ronchetti doesn't know why people build dark brown houses in the woods. He thinks they're depressing. He adds skylights to lighten the interiors and bring the outside in.

Another home he designed takes advantage of a completely different climate, in the shadow of the Olympic range north of Vancouver. The owners, a retired pilot and a flight attendant, enjoy their deck aerie high on the edge of a cliff. "Once when I visited, I found them perched on a ledge I'd added for cleaning the windows!" he marvels.

Adapting living spaces to the outdoors isn't difficult, Ronchetti insists. In Hawaii, for example, you can find house designs from all parts of the world. With shutters and blinds to keep out the heat," he jokes, "all you need is to let the breeze through and a mai tai, and what you end up with is really a 'green' house for people with more funds."

His philosophy of taking advantage of the local conditions extends to landscaping, too. In Baja, for example, he could take desert plants and make them look as lush, colorful, and luxurious as a tropical rain forest—when they're used appropriately. Applying this principle to houses, he says, "Don't try to defeat the prevailing conditions but, instead work with them. Let them teach you something. All is at ease with itself, but it doesn't mean the house can't have panache."

For Ken Ronchetti, it's a very personal and richly rewarding process. He says he knows when he's done a good job when *all* of his clients think he did his best work for *them*.

left
Ken Ronchetti's home features a variety of pools and rivulets, shady palms, and gauzy drapes—theatrical as well as practical.

Raun Thorp, Tichenor and Thorp
BODNER AND OLECKI HOUSE
THORP HOUSE

Karen Bodner and Michael Olecki's house was designed by Spiros Ponti around 1936 and labeled Spanish Revival, but designer Raun Thorp thinks it's more a hybrid of Spanish, Deco, and neo-Portuguese. Like Ponti's other houses, it is charming and full of interesting treatments and details. And it includes one of his signature features: an outdoor courtyard complete with a fireplace.

After a damaging earthquake, Tichenor and Thorp were called in to remodel and renovate the outdoor space, but the owners were adamant about one thing—keeping the very old wisteria that scaled a large arbor in the courtyard. "Everything," Thorp emphasizes, "absolutely everything was predicated on saving that wisteria." The designers enlisted the help of an arborist, who advised them on how best to protect the plant as renovation got underway.

Careful to maintain Ponti's distinctive style, Thorp said they restored what was there and added new things, like the built-in benches and the fountain, which Thorp designed and cast in poured-in-place concrete.

They rebuilt the fireplace and added touches like the Moroccan plate above it. The new wall is plastered reinforced concrete block. The new tiles are similar to what Ponti himself would have used. The flooring was removed and replaced with broken concrete pavers, stained and set in sand, so water could drain through to nourish the treasured wisteria's roots. New outdoor speakers were installed behind original cabinet doors.

right
Luncheon becomes truly special when served on
Moroccan *zelige* tiles beneath a magnificent wisteria.

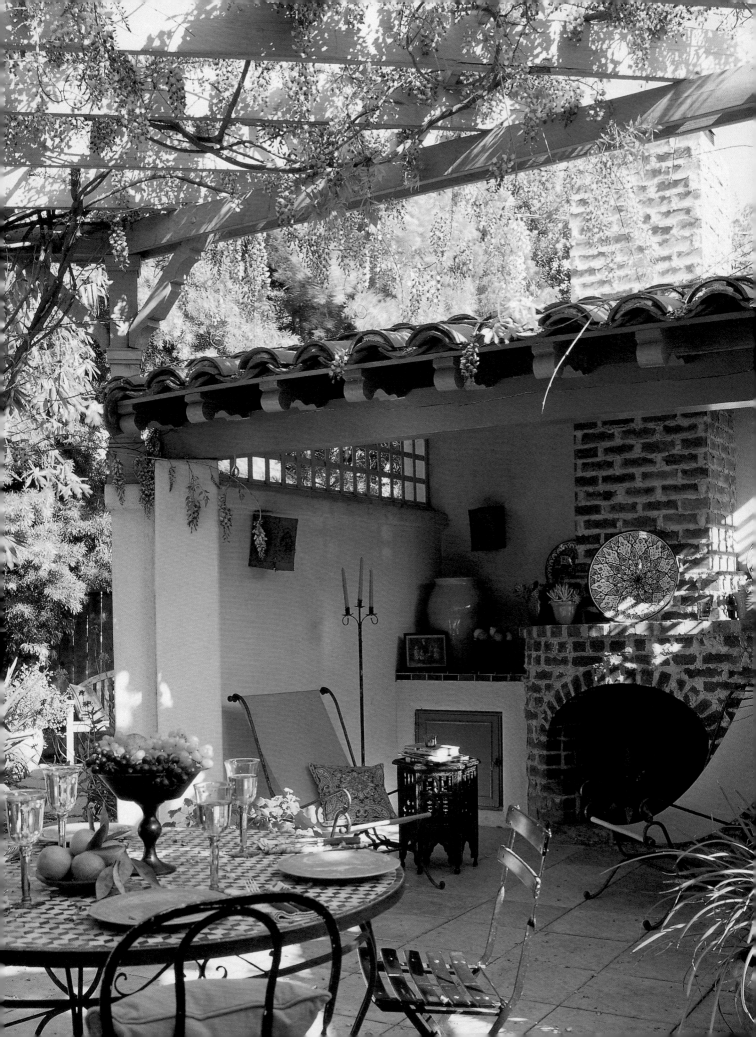

Designers Tichenor and Thorp applied their skills to
their own backyard. They positioned their cabana to
disguise the rubber tree's massive roots and provide
a cool, comfortable place of repose by the pool.

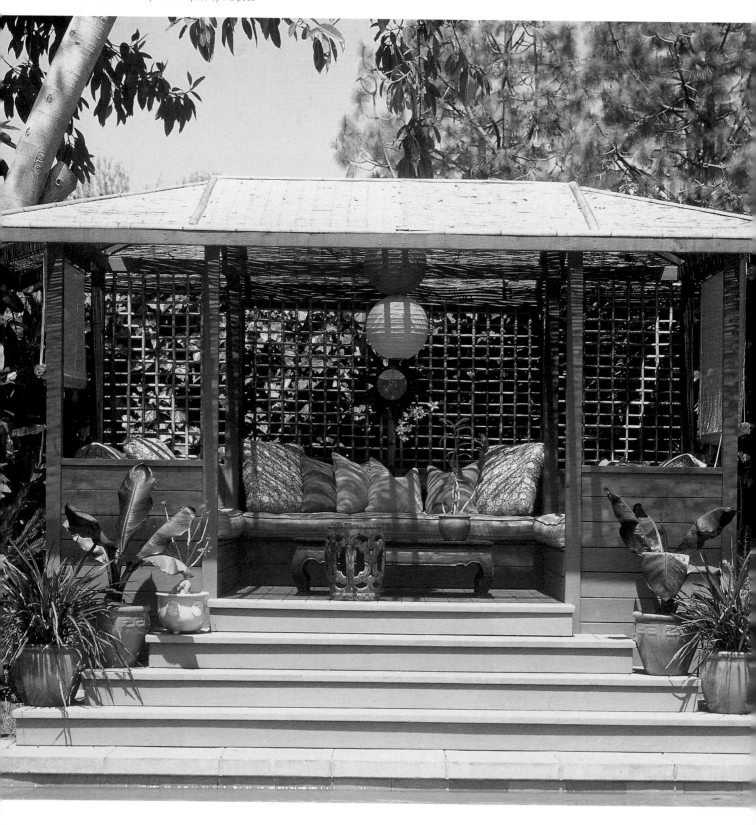

Moroccan *zelige* tiles adorn the top of the iron table with its matching chairs. Decorative pillows add to the exotic theme. Then the designers landscaped the space using succulents to save water, as well as orange epidendrons, bamboo, and rosemary in a private Japanese garden they tucked into one corner. Everything encircled and enhanced the aristocratic wisteria, whose purple blossoms dripped from the arbor and perfumed the air.

Then, on a final day of construction, a laborer severed the root of the wisteria. An emergency visit by the arborist was to no avail. The cherished wisteria was dead. However, the structure of the plant remained and new wisteria were planted around it. The young vines latched onto the old and climbed to the top of the arbor, where today they are indistinguishable from the original. Disaster averted; client happy.

Raun Thorp is a passionate advocate for outdoor living spaces, and the firm she owns with her husband is known for the outdoor rooms they create. She incorporated her ideas to great effect on her own property when she undertook a renovation of the yard.

"When property sizes in are small," she notes, "you want to take full advantage of all of it. Using the outdoors is a way to extend the house. It gives you many more options for entertaining and relaxing." She finds that, paradoxically, dividing up the outdoor space into discrete "rooms" makes the whole seem somehow bigger. She creates destinations, like her cabana, and is conscious of vistas. When she's relaxing on her daybed, she contemplates the lily pond across the pool.

"Outdoor rooms create a real sense of place," says Thorp. "They invite people to use them. If all you have is a green lawn with a border, there's no reason to go out there, unless you're five years old."

directory of resources

DIRECTORY OF DESIGNERS

Cliffside Design (page 78, 88)
Rick Botieri
34 Alden Street
Plymouth, MA 02360
508-746-0074
www.cliffsidedesign.com

Santa Fe House, NM (page 130)
Carla and Gerrit Cormany

Santa Barbara House, CA (page 120)
Arn Ginsburg
arnginsburg@yahoo.com

Garage House, Carpinteria, CA (page 124)
Ann Knudsen
Knudsen Design Studio
Los Angeles, CA
323-662-1595

Korzen House (page 127)
Kelly Wearstler
KWID
317 North Kings Road
Los Angeles, CA 90048
323-951-7454 (voice)
323-951-7455 (fax)
www.kwid.com

Mia Lehrer (Korzen House) (page 127)
Mia Lehrer & Associates
3780 Wilshire Boulevard
Suite 1100
Los Angeles, CA 90010
213-384-3844 (voice)
213-384-3833 (fax)
www.mlagreen.com

Mahan Rykiel Associates, Inc.
800 Wyman Park Drive
Suite 310
Baltimore, MD 21211
410-235-6001

Ducket House, Ronchetti House (page 133)
Ken Ronchetti
Ronchetti Designs
P.O. Box 474
Rancho Santa Fe, CA 92067
858-756-1033 (voice)
858-756-9669 (fax)

Bodner and Olecki House, Thorp House
(page 136)
Brian Tichenor
Raun Thorp
Tichenor & Thorp
8730 Wilshire Blvd. (Penthouse)
Beverly Hills, CA 90211
310-358-8444

DIRECTORY OF RESOURCES

accessories/furniture

Adirondack Designs
350 Cypress Street
Fort Bragg, CA 95437
800-222-0343
www.adirondackdesign.com

Anna French Ltd.
343 Kinds Road
London SW3 5GS England
0207-351-1126
To the Trade Only
(fabric)

Anthropologie
235 S 17th Street
Philadelphia, PA 19103
215-564-2313
www.anthropologie.com

Aria
295-6 Upper Street
London N1 2TU
020 7704 1999
(contemporary furniture and accessories)

Archie's Island Furniture
48 Everett Avenue
Winchester, MA 01890
800-486-1183
www.outdoormodern.com

Atlantic Yard
2424 East Las Olas Boulevard
Fort Lauderdale, FL
877-552-3516
www.atlanticyard.com
(garden products)

Avant Garden
The Studio
3 Dartmouth Place
London W4 2RH
United Kingdom
020 08747 1794

Brown Jordan Co.
9860 Gidley Street
El Monte, CA 91731
626-443-8971
www.brownjordancompany.com
(metal furniture)

Carruth Studio
1178 Farnsworth Road
Waterville, OH 43566
www.carruthstudio.com
(cast-concrete and terra-cotta statues)

Charleston Gardens
P.O. Box 20730
Charleston, SC 29413
800-469-0118
www.charlestongardens.com

Classic Garden Ornaments
Longshadow Gardens
83 Longshadow Lane
Pomona, IL 62975

Colonial Williamsburg
P.O. Box 3532
Williamsburg, VA 23185
800-446-9240
www.williamsburgmarketplace.com
(accessories)

Country Casual
17317 Germantown Road
Germantown, MD 20874
301-540-0040
www.countrycasual.com
(high-quality teak furniture)

Crate & Barrel
311 Gilman Avenue
P.O. Box 9059
Wheeling, IL 60090
800-451-8217
www.crateandbarrel.com

Dominic Capon
Unit 9, Imperial Studios
Imperial Road
London SW6 2AG
United Kingdom
(accessories from India and Vietnam)

Durasol Systems, Inc.
197 Stone Castle Road
Rock Tavern, NY 12575
914-778-1000
888-822-0383
www.durasol.com
(retractable awnings)

Jacqueline Edge
1 Courtnell Street
London W2 5BU
United Kingdom
020 7229 1172
(ornaments, loungers, bamboo deckchairs)

Elizabeth Street Gardens & Gallery
1176 Second Avenue
New York, NY 10021
(nineteenth-century French cast-iron
sculptures, decorative urns, etc.)

Ethan Allen
Ethan Allen Drive
P.O. Box 1966
Danbury, CT 06813
800-228-9229
www.ethanallen.com
(furniture)

Florentine Craftsmen Inc.
46-24 28th Street
Long Island City, NY 11101
(lead and cast-iron furniture
and ornaments)

French Wyres
P.O. Box 131655
Tyler, TX 75713
903-561-1752
www.frenchwyres.com
(wire furniture and plant stands)

Garden Concepts Collection
P.O. Box 241233
Memphis, TN 38124
901-756-1649
www.gardenconcepts.net

Gardener's Eden
1655 Bassford Drive
Mexico, MO 65265
800-822-9600

Gardener's Supply Co.
128 Intervale Road
Burlington, VT 05401
800-836-1700
www.gardeners.com

Gaze Burvill
Newtonwood Workshop
Newton Valence
Alton, Hampshire GU34 3 EW
England
01420 587467
www.gazeburvill.com
(high-quality contemporary furniture)

The Glidden Company
925 Euclid Avenue
Cleveland, OH 44115
800-221-4100
www.gliddenpaints.com

Gloss Ltd
274 Portobello Road
London W10 5TE
United Kingdom
020 8960 4146
e-mail: pascale@glassltd.u-net.com
(soft furnishings)

Home Depot
www.HomeDepot.com

Ikea
1100 Broadway Mall
Hicksville, NY 11801
519-681-4532
www.ikea.com
(Scandinavian-style furniture)

Barbara Israel Garden Antiques
296 Mount Holly Road
Katonah, NY 1053
212-744-6281
www.bi-gardenantiques.com
(period American and European antiques)

Kingsley-Bate
5587B Guinea Road
Fairfax, VA 22032
703-978-7200
www.kingsleybate.com
(high-quality teak furniture)

Cath Kidston
8 Clarendon Cross
London W11 4AP
020 7221 4000
www.cathkidston.co.uk
(vintage & floral fabrics, furniture
and accessories)

Lister Lutyens
Hammonds Drive
Eastbourne, East Sussex BN23 6PW
England
01323 431177
www.lister-lutyens.co.uk
(high-quality teak furniture)

Kenneth Lynch & Sons
84 Danbury Road
Wilton, CT 06897
203-762-8363
www.lkynchsons.com
(garden ornaments)

Malabar
31-3 South Bank Business Centre
London SW8 5BL
United Kingdom
020 7501 4220
(Indian silks and natural cottons)

Maine Cottage Furniture
P.O. Box 935
Yarmouth, ME 04096
207-846-1430

Maine Millstones/Royal Stonework
Southport, Maine 04576
207-633-6091
(fountains)

McKinnon & Harris, Inc.
P.O. Box 4885
Richmond, VA 23220
804-358-2385

Meyers Imports
215 Frobisher Drive
Waterloo, ON, Canada, N2VV 2G4
800-267-8562
(importer of European garden products)

Minh Mong
182 Battersea Park Road
London SW11 2RW
United Kingdom
020 7498 3233
e-mail: minhmong@lineone.net
(Vietnamese and Cambodian silks)

The Modern Garden Co.
Hill Pasture, Brosted, Great Dunmow
Essex CM6 2BZ
London
United Kingdom
www.moderngarden.co.uk
(modern garden furniture in plastic,
steel, aluminum, concrete, and
contemporary fabrics)

Natural Decorations, Inc. (NDI)
777 Industrial Park Drive
Brewton, AL 36426
800-522-2627
www.ndi.com

Gerald Parker
Manomet, MA
www.supremephotography.net

Pier 1 Imports
800-245-4595
www.pier1.com

Pottery Barn
P.O. Box 379905
Las Vegas, NV 89137
800-588-62509
www.potterybarn.com

Roche-Bobois
Boston, Washington DC,
Palm Beach, Miami, Naples
305-444-1017
www.roche-bobois.com

Seibert & Rice
P.O. Box 365
Short Hills, NJ 07078
973-367-8266
www.seibert-rice.com
(terra-cotta pots)

Smith & Hawkin
P.O. Box 431
Milwaukee, WI 53201
800-776-3336
www.smithandehawken.com

Stone Forest
Department F
P.O. Box 2840
Santa Fe, NM 87504
505-986-8883
(hand-carved granite, Japanese
traditional design)

Vermont Outdoor Furniture
Barre, VT
800-588-8834
www.vermontoutdoorfurniture.com
(northern white cedar furniture)

The Wicker Works
267 Eight Street
San Francisco, CA 94103
415-626-6730
(high-quality teak and wicker)

Whisper Glide Swing Company
22233 Keather Avenue North
Forrest Lake, MN 55025

lighting

The Lighting Edge/Altec Lighting
50 West Avenue
P.O. Box 925
Essex, CT 06426
860-787-8968
www.lightingedge.com

Architectural Area Lighting
14249 Artesian Boulevard
La Mirada, CA 90638
704-994-2700
www.aal.net

Dover Design Inc.
2175 Beaver Valley Pike
New Providence, PA 17560
(handcrafted copper landscape lights)

Escort Lighting
51 North Elm Street
Wernersville, PA 19565
800-856-7948

Hanover Lanterns Terralight
470 High Street
Hanover, PA 17331

Liteform Designs
P.O. Box 3316
Portland, OR 97208

Stonelight Corp.
2701 Gulf Shore Boulevard North
Naples, FL 33940

paving, walling, timber and stone

Anchor Block Co.
2300 McKnight Road
North St. Paul, MN 55109
651-777-8321
www.anchorblock.com

Ann Sacks Tile and Stone
115 Steward Street
Seattle, WA 98101
www.annsacks.com

Bamboo Fencer
179 Boylston Street
Jamaica Plain, MA 02130
617-524-6137
www.bamboofencer.com

Classical Flagstones
Lower Ledge Farm
Doynton Lane
Dyrham, Wilshire, SN14 8EY
United Kingdom
www.classical-flagstones.com

Cold Spring Granite Company
202 South Third Avenue
Cold Spring, MN 56320
www.coldspringgranite.com

Eco Timber International
P.O. Box 882461
San Francisco, CA 94188
888-801-0855
www.ecotimber.com

Goshen Stone
P.O. Box 332
Goshen, MA 01032
413-268-7171
www.goshenstone.co
(micaschist flagstone)

Halquist Stone
P.O. Box 308
Sussex, WI 53089
800-255-8811
www.limestone.com

Pine Hall Brick Company
P.O. Box 11011
Winston-Salem, NC 27116
800-334-8689
www.pinehallbrick.com
(specialty bricks)

The Timber Source
P.O. Box 100
Winchester, KY 40392
859-744-9700
(info on North American woods
from sustainable forests)

Wausau Tile Inc.
P.O. Box 1520
Wausau, WI 54401
800-388-8738
www.traditional-building.com

structures

Amdega Ltd.
Faverdale, Darington Co.
Durham DL3 0PW
United Kingdom
0800 591523
Design offices throughout the USA
And Canada, 80-0-449-7348
Ireland, Europe and Asia
44-1325-468522
email: info@amedga.co.uk
www.amdega.com
(conservatories and other
garden structures)

The Bank
1824 Felicity Street
New Orleans LA 70113
(architectural elements)

Bow House Inc.
92 Randall Road
Boston, MA 01740
978-779-6464

Dalton Pavilions Inc.
20 Commerce Drive
Telford, PA 18969-1030
215-721-1492
www.daltonpavilions.com

Four Seasons Solar Products
5005 Veterans Memorial Highway
Holbrook, NY 11741-4516
806-368-7732
www.four-seasons-sunrooms.com

Trellis Structures
P.O. Box 380
Beverly, MA 01915
978-921-1235
www.trellisstructures.com

Vixen Hill Gazebos
Main Street
Elverston, PA 19520
800-423-2766
www.vixenhill.com

Outdoor Decorating and Style Guide photographer credits

Courtesy of Amdega, Ltd., 25; 36; 37; 39; 49; 99; 115

Anna French, Ltd, 56

Jan Baldwin/Homes and Gardens/
IPC Syndication, 94

Antoine Bootz, 15 (top)

Courtesy of Charleston Gardens, 66; 67; 81 (bottom); 91

Courtesy of Classical Flagstones, 28

Philip Clayton-Thompson/Donna Pizzi, Stylist, 58; 59; 86

Grey Crawford, 121; 122; 123; 127; 128

Guillaume de Laubier, 6 (bottom); 20; 22; 40; 48; 52; 54; 61; 64; 81 (top); 85; 87; 104; 107; 118 (top)

Carlos Domenech, 8; 53; 65; 110

Carlos Domenech/Luciano Alfaro Design, 118 (bottom)

Carlos Domenech/Keller Donovan, 73

Carlos Domenech/Eddy Garcia Austrich, 84

Carlos Domenech/Marco Guinaldo Design, 119

Carlos Domenech/Jorge Hernandez Architect, 75

Carlos Domenech/Kemble Interiors, 23; 31; 62

Carlos Domenech/Jane Reeves Design, 89

Carlos Domenech/John Telleria Design, 42; 103

Courtesy of The Glidden Company, 82; 83

F. Goral/Jahreszeiten-Verlag, 12

Sam Gray/Rick Botieri Design, 78; 88

Reto Guntli, 15 (bottom)

Ron Haisfield/Courtesy of Mahan Rykiel Associates Inc., 18 (bottom)

Mick Hales, 9; 38; 71

John Hall, 76; 77; 109

Courtesy of Mahan Rykiel Associates Inc., 18 (top)

Courtesy of Maine Cottage Furniture, 47

Shelley Metcalf, 50; 92; 97; 131; 132; 133; 134

Courtesy of Natural Decorations, Inc. (NDI), 4

Gerald Parker, 60 (bottom); 72

Courtesy of Pier 1 Imports, 60 (top three); 80; 95

Courtesy of Roche-Bobois, 29

Eric Roth, 6 (top); 16; 19; 27; 33; 34; 100; 101; 113; 114; 117

Jeremy Samuelson, 10; 14

Frederick R. Stocker, 44; 45

Tim Street-Porter/www.beateworks.com, 21; 68; 93; 106

Brian Vanden Brink, 11

Dominique Vorillon, 137; 138

Deborah Whitlaw, 125; 126

acknowledgments and about the author

The making of *Outdoor Decorating and Style Guide* was truly a collaborative effort. I would like to thank Martha Wetherill for developing the concept of *Outdoor Decorating and Style Guide* and Shawna Mullen for passing the project along to me. Susan Morgan deserves kudos for writing the book's first chapter (most of which is printed here as Chapter One). Photo editor Betsy Gammons did an amazing job gathering images. Thanks to the photographers whose images appear here, particularly those who resubmitted transparencies. Anita Llewellyn expertly came to our aide, authoring the projects section, when time was running out—thank you. And thanks to Kristy Mulkern and Barbara Rummler for their expertise and dedication to this project. Thanks also to David Martinell and Cora Hawks.

NRG

Nora Richter Greer is an architecture and design critic whose professional writing career began in 1977 at *Architecture* magazine. Since then she has written for numerous magazines and newspapers, as well as contributed to and authored more than a dozen books on architecture, urban design, and interior design. With advanced degrees in journalism and creative writing, Ms. Greer resides in Washington, D.C.